Garden Birds

A Daleguild book designed by Alan Vanbeek-
Anthon and produced for Windward, an imprint
owned by W.H. Smith & Sons Limited, trading as
W.H.S. Distributors, Euston Street, Freemen's
Common, Aylestone Road, Leicester.

Illustrations: © 1979 Maurice Pledger/Linden Artists

Text: © 1979 Daleguild Limited

ISBN 0 7112 00009

Garden Birds

Illustrated by Maurice Pledger

Text by Michael Chinery

WINDWARD

I dedicate this book to my Mother and Father.

Maurice J. Pledger.

FOREWORD

*P*ERHAPS only once in a generation does an artist of outstanding ability emerge to rise above the heads of his contemporaries; such an artist is Maurice Pledger.

His illustrations of birds have lead him to be compared to the great Audubon, who brought a new dimension to ornithological illustration more than a century ago.

Maurice's knowledge of his subject is reflected in his work. He is a true countryman, who is at his happiest walking through the woods and fields around his home. Here he observes the wild life he knows so well and loves to paint.

For all those who love birds and nature, his illustrations are a joy to behold. The fine detail and accuracy of colour are the outstanding hallmarks of his work. A very modest man, Maurice is quick to praise the work and ability of his fellow artists. He is a great admirer of the painter Basil Ede, who encouraged Maurice to develop his prodigious talent.

David C. Tennant
Publisher

INTRODUCTION

*I*T is inconceivable that there is any garden that does not get at least some bird visitors. This was vividly brought home to me one winter when visiting a house in the middle of a new estate. Building was going on everywhere, the garden was a mosaic of mud and puddles, and the only vegetation to be seen was an occasional blade of grass and a few dandelion leaves. Not the most encouraging scene for the bird-watcher, perhaps, but the birds themselves are not easily discouraged and a pair of reed buntings spent quite a while hopping around the puddles and searching for seeds. These birds have been described by some ornithologists as the least attractive of our native species, but they were certainly a most welcome sight on that soggy afternoon.

It will be a long time before the garden referred to above is mature enough to support the rich variety of bird life seen in this book, but the gardener can do much to encourage bird visitors by planting shrubs and by putting out a variety of foods. Blackbirds and blue tits will visit even the barest gardens if they know they can find food there, and so, of course, will the ubiquitous house sparrows and starlings. Kitchen scraps will attract all these birds, but you can bring in many more species and add greatly to your enjoyment of your garden by providing assorted seeds and strings of peanuts. As the shrubs grow, they will provide food and shelter for even more birds, and perhaps even nesting sites. If you are lucky enough to have a mature garden with birds nesting in it, do resist the temptation to peer into the nests. This may well cause the birds to desert, thus depriving you of further pleasure, and interference with nesting birds is, of course, illegal. Watch from a distance, preferably with binoculars, and you will derive much satisfaction from seeing the birds bringing food for their young. With luck, you may even witness the youngsters' first flying lessons.

ALL of the birds which Maurice Pledger has depicted in his beautiful paintings can be found in gardens from time to time, although some are primarily woodland birds. Maurice has painted them in their characteristic attitudes, and I have attempted to complement the paintings with basic information on feeding and nesting habits. I have also given brief information on the birds' voices, which often provide the first clues to the presence of particular species in an area. It is important to differentiate between songs and calls. Songs are used mainly by males to establish and defend territories, and they are therefore rather loud and they tend to be continuous or repeated over and over again. They are heard mainly in the breeding season. Calls are much shorter bursts of sound, used as warning or contact signals. I have described both songs and calls where possible, but it is difficult to put the sounds into words and I recommend readers wishing to learn more about bird songs to obtain some of the excellent recordings which are now available.

Michael Chinery

The
Magpie

MAGPIE

Pica pica

THE magpie is a very striking member of the crow family, easily recognised by its long tail—as long as the rest of the body—and its bold markings. It is often described as a black and white bird, but the dark feathers actually have beautiful green and purple sheens on them. The bird is found throughout Europe and most of Asia, and also in western North America, where it is known as the black-billed magpie. It frequents woodland margins, agricultural land, parks, and large gardens, often coming well into built-up areas. Several dozen magpies may assemble in the spring, but the birds are more often seen singly or in pairs. They spend much of their time on the ground, where they often hop with a curious sideways movement. They frequently display to each other by raising the wings and tail as shown in the plate. There is no real song, but the birds make many harsh chuckling and chattering noises.

Magpies feed mainly on insects, but the stout beak is able to deal with a wide variety of foods, both animal and vegetable. Lizards, mice, and young rabbits are sometimes eaten, and the birds even kill adders on occasion. They are particularly fond of raiding other birds' nests and eating the eggs or nestlings. Like other crows, the magpies will also eat carrion, and they can often be seen pecking at the remains of rabbits and other animals squashed on the roads. In farming country they sometimes perch on the backs of sheep and remove ticks and other parasites. Vegetable foods include large quantities of grain, together with various nuts and softer fruits.

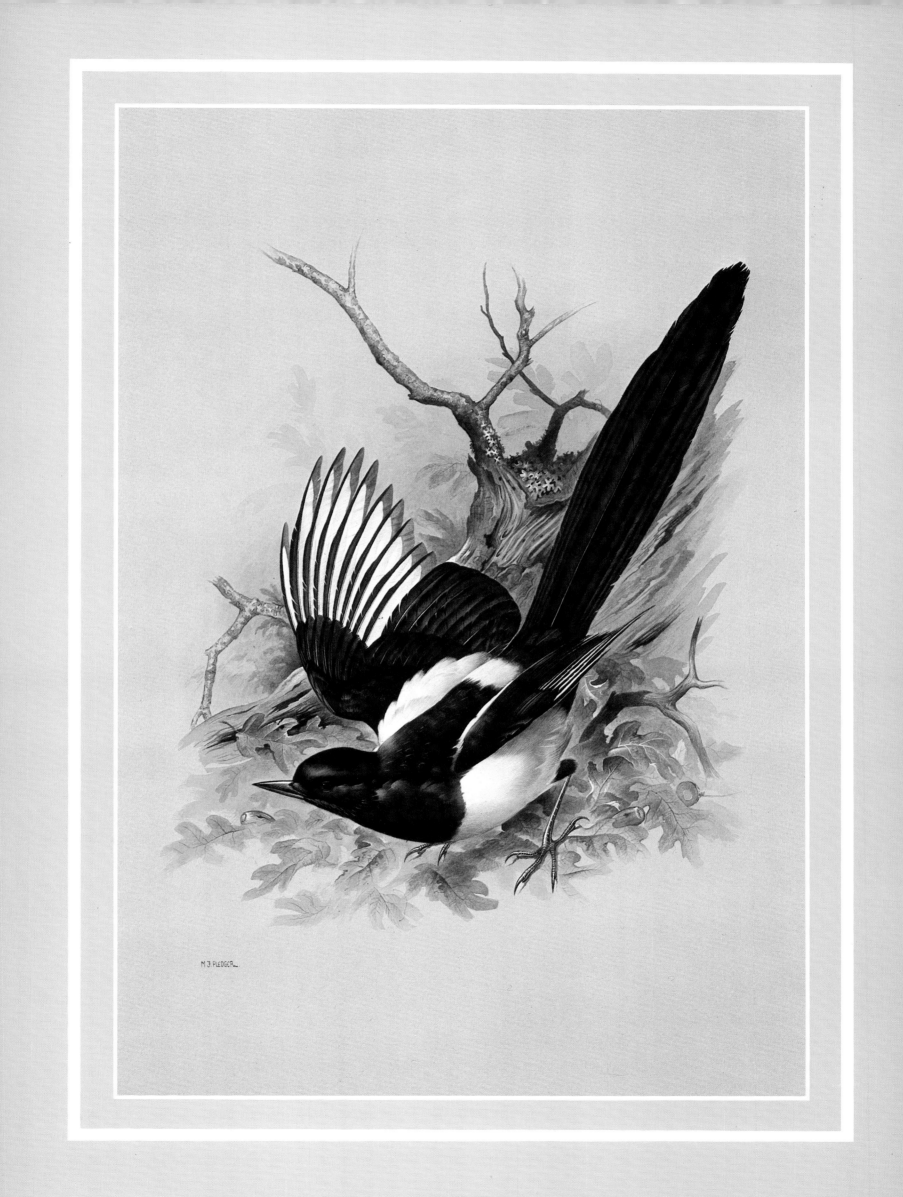

BREEDING usually begins in April, although it may start earlier in the more southerly regions. Male and female combine to make a large nest in a tall hedge or bush, or sometimes in an orchard or a park tree. In built-up areas they may even choose buildings. The outside of the nest is made with coarse twigs, and looks rather untidy. The twigs are cemented with mud, and the cup is lined with fine roots, grass, and hair. A dome of coarse and often thorny twigs is added, making a ball-shaped nest with a rather small entrance hole on one side. The male brings all the nesting material, but the female does most of the construction work.

When the nest is complete, the female lays about six greenish-blue eggs which are heavily speckled with brown. She incubates them for about 18 days, during which time the male brings all her food. The nestlings are then fed by both parents for about a month, the main foods brought to them being caterpillars, beetles, and flies. The youngsters resemble the adults in colour when they leave the nest, but they have shorter tails.

Magpies are well known for their habit of collecting bright objects and hiding them in their nests or elsewhere—a habit that they share with their relatives the jackdaws. There is no real explanation of this strange behaviour, unless the magpie takes the objects in the belief that they are colourful fruits, but the thieving magpie really does exist.

Length: 46 cm (including tail)
Sexes similar
Voice: a harsh chattering

The Pied Wagtail

PIED WAGTAIL

Motacilla alba

THE pied wagtail is an unmistakable small black and white bird, often seen scampering over the lawn. The female, seen at the top of the picture, has a greyer back than the male and slightly less black on her head, but otherwise the sexes are very similar. Pied wagtails are almost confined to the British Isles and are actually a race of the much more widely distributed white wagtail. The latter tends to have a greyish back in both sexes. It is found throughout Europe, although absent from the north in winter.

Pied wagtails like to live in open country, especially farmland and areas near water, but they also occur commonly in town parks and in gardens and, although they do not breed in heavily built-up areas, large flocks sometimes come into towns to roost at night. The birds are particularly common in and around farmyards, where the buildings provide plenty of nesting crannies and the manure heaps attract hordes of small insects on which they can feed.

The slender beak is typical of insect-eating birds and is used mainly to catch flies and other small insects on or just above the ground or the water. The birds sometimes perch in trees, but they spend most of their waking hours on the ground, walking with a characteristic jerky gait, head and tail both bobbing in time to the step. The tail continues to wag even when the bird is standing still. Every now and then a wagtail rushes forward with head, body, and tail all held parallel to the ground. The rush may end with the bird snapping up a small insect, which its keen eyes had picked out several metres away, and the tail wagging furiously to maintain balance. Quite often, however, the insect disappears before it can be caught, and the bird seems to be dashing about for fun—a sudden burst of speed for no apparent reason.

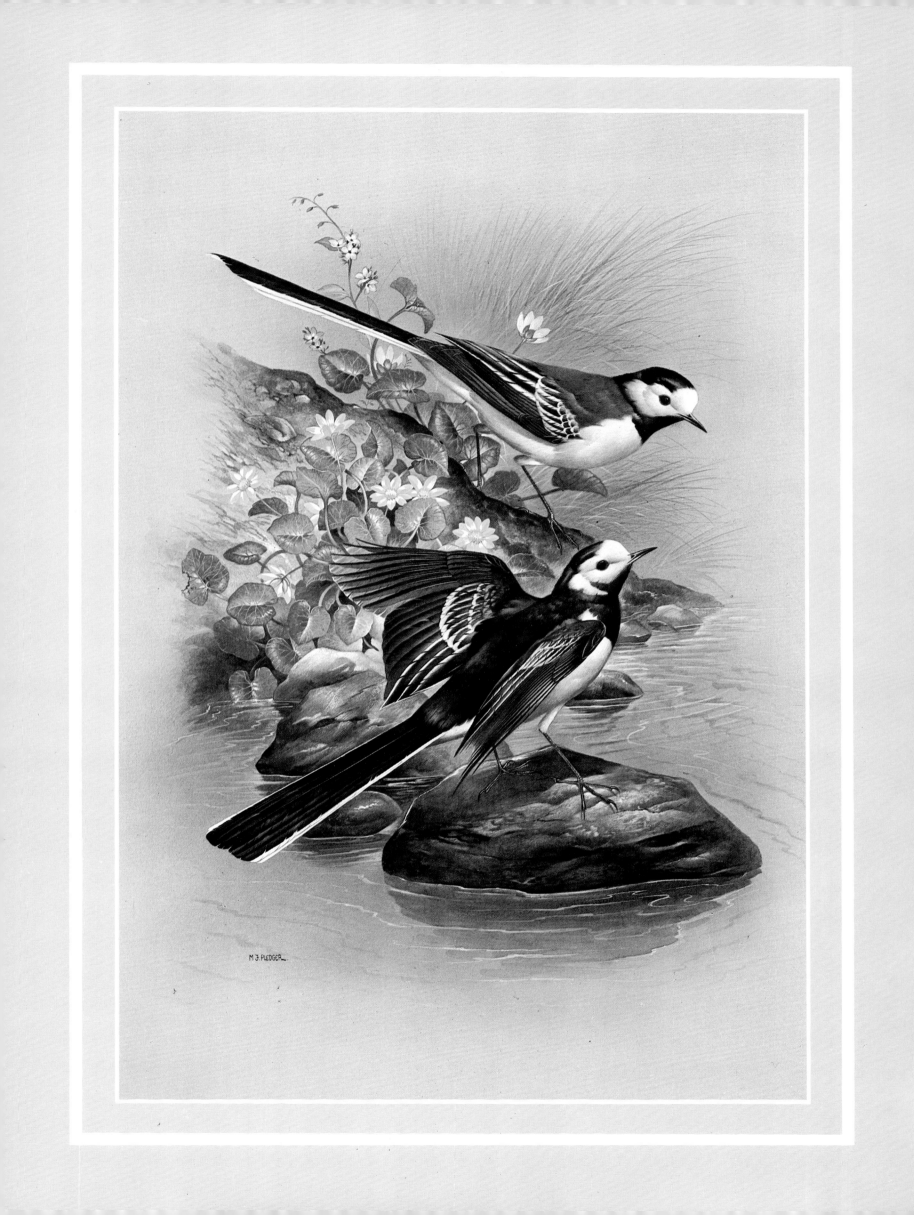

*P*IED wagtails sometimes fly high into the air, but most of their flights are within a few metres of the ground. Bursts of flapping punctuate long glides, giving the flight a characteristic undulating appearance, although the 'wavelength' is much longer than we see among the finches. The long tail acts as both rudder and brake, enabling the bird to perform some astonishing aerobatics to snap up insects in flight.

Most specialist insect-eaters, such as the swallow and the cuckoo, have to migrate south for the winter, but the wagtail is just able to survive all year in Britain because it can collect insects on the ground and usually finds something to eat as long as the ground is not snow-covered. Many die in severe weather. The wagtails of northern Europe, where the ground is always frozen in winter, always fly south in the autumn.

Nest-building usually starts in April—somewhat later in the north—and is carried out entirely by the female. The nest is built in a cavity in an old wall or bank or some similar situation, and it is made of twigs, grass, and moss. It is lined with hair, wool, or feathers. Four to six greyish, freckled eggs are laid and incubated for about two weeks by the female, sometimes with a little help from her mate. The nestlings are fed by both parents and leave the nest after two weeks, although they continue to be fed. They stay as a family for several weeks. In southern regions there may be two, or even three broods. The male feeds the older youngsters while the female incubates the next clutch.

Length: 18cm

Song: A twittering noise based on the high-pitched calls of 'chizzick' and 'chick'

The Hawfinch

HAWFINCH

Coccothraustes coccothraustes

THE hawfinch is the second largest of the European finches, being exceeded in size only by the pine grosbeak from the northern coniferous forests. Its massive beak and heavily-built head and neck give it a very top-heavy appearance and make it instantly recognisable. The hen, which is the upper of the two birds in the plate, is less brightly coloured than the male, and she often has a distinct greyish tinge. Her beak is also greyish throughout the year, while that of the male becomes bluish in the summer.

Hawfinches range from Britain and southern Scandinavia to North Africa and across central Asia to Japan, but they are absent from Ireland. The birds in the eastern parts of the range are much paler than those in the west. Hawfinches can be found in orchards, parks, and gardens with large trees, but they are primarily birds of the deciduous and mixed forests. They are especially common in the beech and hornbeam forests of central Europe, although there is a distinct south-westerly movement during the autumn.

The birds are predominantly seed-eaters, and the great beak, worked by powerful, bulging muscles in the head and neck, is able to deal easily with such hard objects as cherry stones and the hard inner fruits of the hawthorn and the holly. The inside of the beak is strongly ridged and it holds the fruit very securely while the pressure is applied to crack it. The main foods are the fruits and seeds of woodland trees, including beech, sycamore, hornbeam, and cherry. They are plucked from the branches as they ripen in the summer, and collected from the ground in the autumn and winter. The birds also invade orchards to feed on cherries, apples, and other fruits, and the hedgerow hips and haws keep them happy for a while in the autumn and early winter. Later in the winter, as the seeds run out, the hawfinches turn their attention to the buds of oaks and other trees.

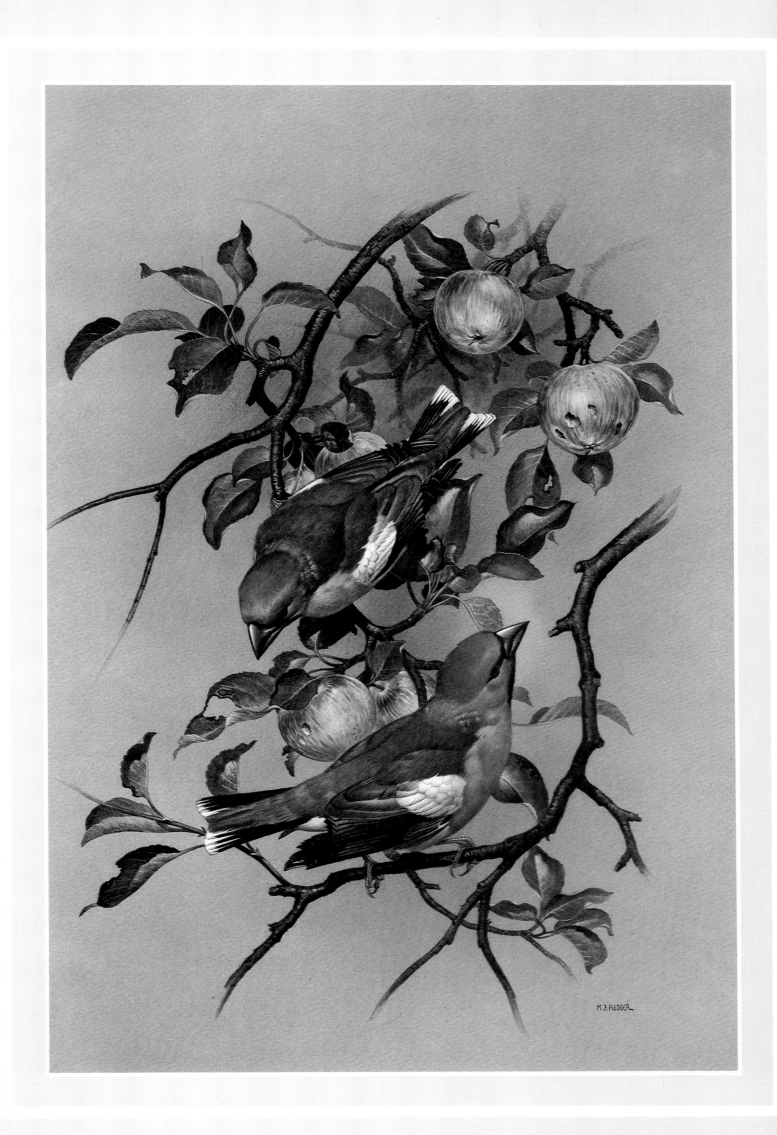

*H*AWFINCHES are most often seen in small groups of up to a dozen birds, even in the breeding season, but they are very wary when on the ground and not at all easy to approach: at the first hint of danger they fly into the trees. They keep in contact among the branches by means of a rather thin call of *zee-zee-zee*, and when they come down again they descend very slowly, a branch at a time. The small flocks roam from one wood to another in the winter, although they will stay put for weeks around one group of trees as long as the food holds out. The birds utter a sharp call of *tzick* or *tzick-ick* as they fly, but they have no obvious song.

The birds in the winter flocks gradually pair off in readiness for the breeding season, which usually starts at about the beginning of May. It is quite usual for five or six pairs to nest in close proximity to each other, forming a rather loose colony. The immediate vicinity of each nest is defended against neighbouring birds, but the hawfinches remain sociable and generally forage together at some distance from the nest. On other occasions a pair may nest alone and defend a much larger territory in which they are able to collect all of their food.

The nest is generally built in a tree, rarely less than three metres above the ground and usually placed on a stout branch. It consists of a rough outer cup, often little more than a platform of twigs, and shallow inner cup made of roots, lichens, hair, and plant fibres. The male often collects material, but the hen bird does all the building. She then lays five eggs as a rule and usually incubates them herself. The eggs hatch after about twelve days, and both parents then feed the nestlings with a mixture of seeds and insects. The young birds leave the nest when they are about two weeks old.

Length: 18cm
Voice: Commonest call is a sharp flight call of 'tzick' or 'tzick-ick'

The Swallow

SWALLOW

Hirundo rustica

THE swallow, known as the barn swallow in North America, is one of the world's most widely distributed birds. It breeds over much of the northern hemisphere and, being an insect-eating species, it migrates to warmer regions for the winter. European birds travel as far as South Africa, while North American birds reach Argentina and Asiatic swallows go as far as Australia.

Swallows spend most of the daylight hours on the wing, and they can regularly be seen swooping through the air over our gardens in the summer. They range from ground level to about 150 metres, and they are always on the look-out for mosquitoes and other small insects with which to feed themselves and their young. They scoop them from the air with the short, gaping beak. A swallow may catch well over 2,000 mosquitoes in a single day, and make more than 300 visits to the nest each day to feed the young. It is difficult to see any colours when the birds are silhouetted against the sky, but the swallows can always be recognised by their long, forked tails. Close to, you can see the red throat patch, the white belly, and the metallic blue of the back. The sexes are very similar, but the female, seen at the nest in the plate, is slightly darker and she has a very slightly shorter tail.

Swallows arrive at their breeding grounds in March and April as a rule, and they can be seen flying over farmland, open grassland, marshes, and inland waters as well as over gardens.

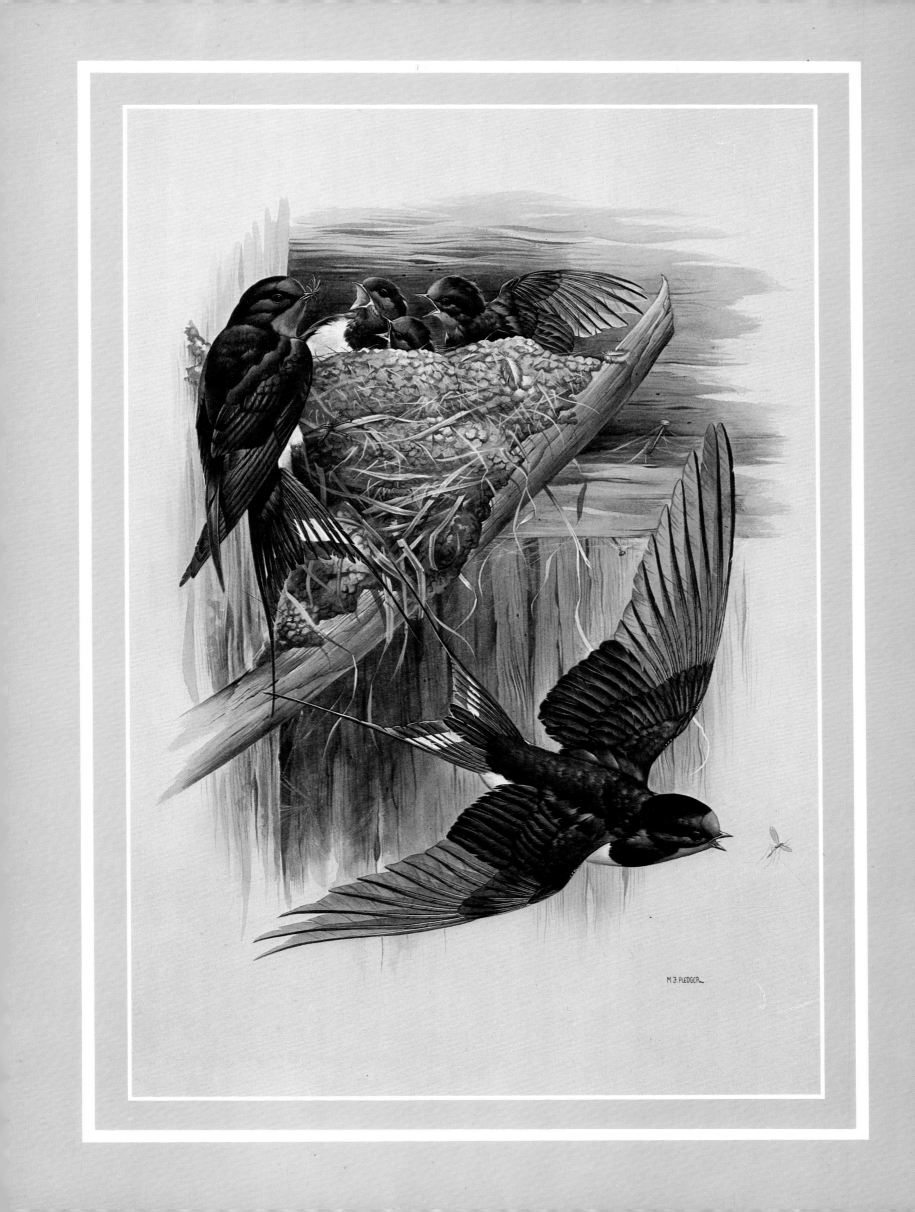

*T*HEY skim low over water to drink in flight as well as to catch the numerous insects that gather there. They keep mainly to the lowlands, and they do not commonly nest in large towns, although they prefer to perch on wires and buildings than in trees. The lack of insects and the lack of mud for their nests are the main reasons for the lack of swallows in towns.

The nest is usually built on some kind of ledge, normally in a building that gives some shelter from the elements. Modern dwelling houses do not provide many suitable nesting sites, but farm buildings, out-houses, railway stations, and church porches are all regularly used. The nest is made of mud and straw and it is lined with feathers. Both parents carry out the building work, and egg-laying begins in May, although in northern areas, it does not start until June. Five eggs is the usual number, but there are sometimes six or seven in the north. There are more daylight hours in the north and the birds can rear more young without difficulty. The eggs are incubated mainly by the female and they hatch after about 14 days. The nestlings are then fed by both parents until they leave the nest after a further three weeks. The adults may continue to feed them in mid-air for a few more days. Two, or even three broods are raised in the more southerly areas.

The return migration begins in August, when hundreds of birds gather on telegraph wires in readiness for the long flight. Their not very musical twittering can be very noisy at such times. The birds stop several times on the journey and the flocks grow continually as tributary streams of swallows join in from all directions. Towns are not avoided on migration, and places like Bangkok and various towns in North Africa are swamped by millions of roosting swallows at night.

Length: 19cm
Voice: A thin twitter

The Blue Tit & Great Tit

BLUE TIT &
GREAT TIT

Parus caeruleus & Parus major

*T*HERE can be few gardens without some of these energetic and attractive little birds. They are on the go almost every minute of the day, flitting from branch to branch and from tree trunk to tree trunk, and hanging in almost impossible positions as they probe every nook and cranny for food. Nowhere do they display their agility better than on the strings of peanuts that we put out for them, and all the time they are uttering their high-pitched calls, most of which are variations of 'tsee-tsee-tsee'.

As well as living in gardens, the birds inhabit woodlands, hedgerows, parks and orchards. The great tit can also be found on heathland. Great tits, seen on the left of the plate, are slightly larger than blue tits, but the two birds are most easily distinguished by the bright blue head and black eye-stripe of the blue tit. The great tit also has a prominent black stripe down the belly, while the blue tit never has more than a very faint stripe and usually has none at all.

The tits are omnivorous birds, eating a wide range of seeds, insects, and other small animals. Insects predominate in the diet during the spring and summer, and caterpillars are especially important during the breeding season, but seeds take over as the main winter foods. Blue tits spend about 85 per cent of the day searching for food during the winter and during the breeding season, while great tits spend slightly less. Small food particles are picked up and swallowed straight away, but larger objects, such as beech nuts and large caterpillars, are deftly held down with one foot and hammered to pieces with the beak.

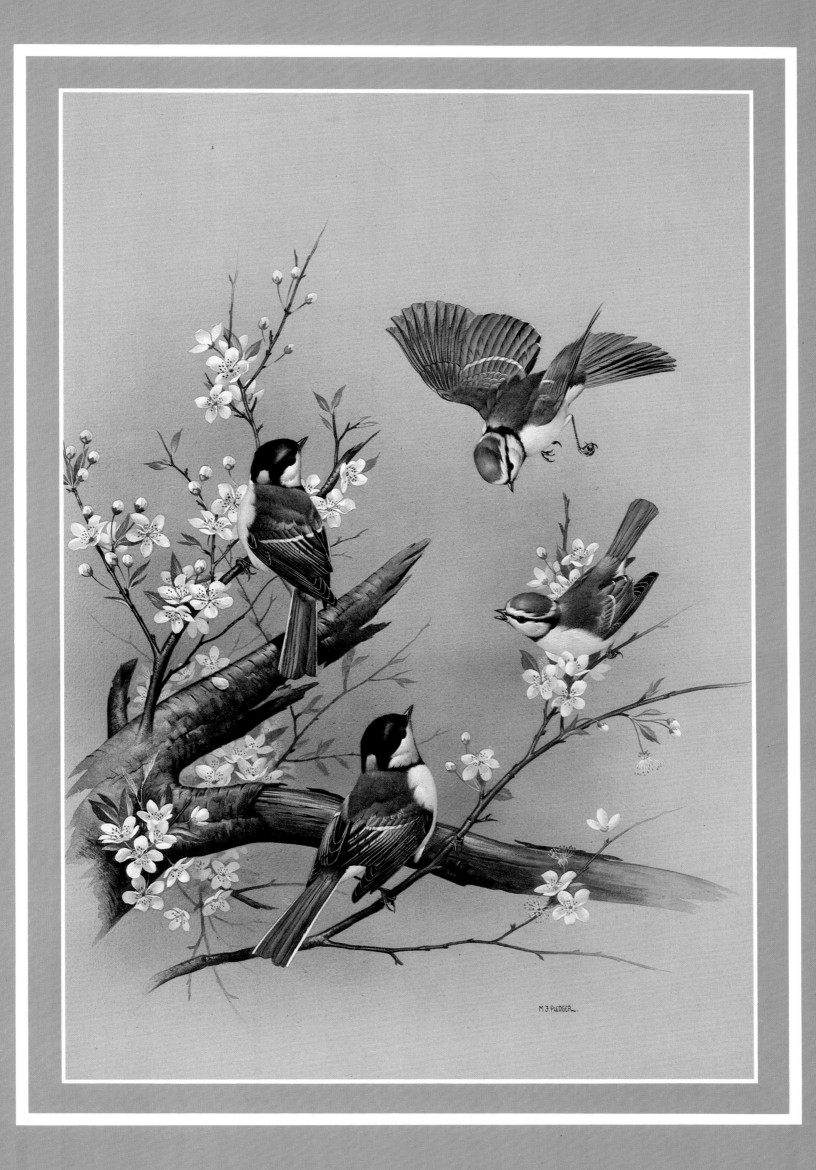

*T*HE sturdy beak of the great tit is strong enough to split hazel nuts. Both blue tits and great tits are well known for their ability to open milk bottles and sip the cream. This habit—a fairly simple extension of their normal inquisitive pecking—was first recorded in Southampton in 1929, but it must have been acquired in many other places as well. Probably just a few birds learned to do it at first, but other individuals watched them and soon began to open bottles for themselves. The habit is now very widespread and indulged in by many species.

Large numbers of great tits and blue tits can be seen in gardens in the winter, but as spring approaches they begin to pair off. A male may even escort his intended back to her roost each night, and the birds gradually come to spend more and more time in their selected territories. Both species nest in holes in trees and walls, and are thus very happy to use the familiar nest-box with its small entrance hole—but they are territorial birds, so do not expect more than one pair of each kind to nest in a typical garden.

The great tit begins nesting in March, and the blue tit begins in April. The female makes the nest alone, using grass, moss, leaves, and other materials. The blue tit lines her nest with feathers, while the great tit generally uses wool or hair. Each species lays up to 12 eggs, generally at a rate of one each day, but incubation does not begin until the clutch is almost or quite complete, for not until then does the hen bird acquire her naked brood patch which will warm the eggs. She incubates alone, although the male brings her food. The eggs hatch after about two weeks of incubation, and the young remain in the nest for about three weeks, during which time the parents may bring 10,000 caterpillars to feed them. You may be lucky enough to see the parents coaxing the youngsters out of the nest for their first flying lesson. A second brood is reared in some areas.

Length: Great tit 14cm
Blue tit 11.5cm
Sexes similar
Voice: A wide range of calls and songs based on phrases like 'tsee-tsee-tsee'

The Chaffinch

CHAFFINCH

Fringilla coelebs

THE chaffinch is the commonest woodland bird of Europe and western Asia. It accounts for between 20 and 40 per cent of the total bird population in nearly all the natural woodlands of Europe. It is especially common in deciduous woods, but it also inhabits coniferous forests and plantations and it is equally at home in parks, gardens, and hedgerows as long as there are some trees. Its wide range of habitats, in fact, makes the chaffinch one of the commonest of all European birds.

The male is easily recognised by its pinkish breast and its slate-blue head and neck. The female, seen in the centre of the plate, lacks the bright colours and could be mistaken for a sparrow, but she can be distinguished by the white shoulder flash and the other white stripes on her wings.

For about nine months of the year the chaffinch feeds almost entirely on seeds. It is particularly fond of beech nuts, but most of its food consists of much smaller seeds. These are nearly all collected on the ground, for the chaffinch rarely sways on plants in the way that the goldfinch does. Seed-eating is abandoned during the breeding season, when the birds turn their attention entirely to insects. Caterpillars are the main food of both nestlings and adults at this time.

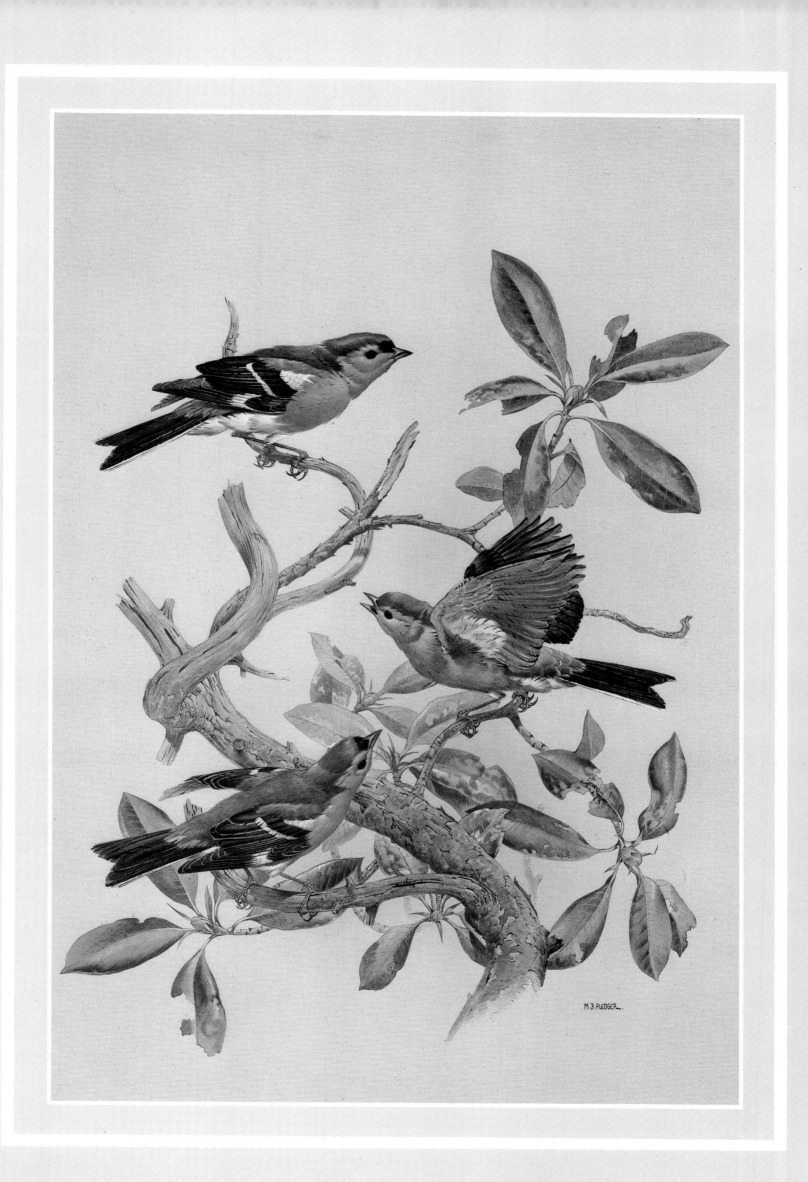

M.J.PLEDGER

*L*IKE many other small birds, the chaffinch maintains a distinct territory during the breeding season. The male begins to establish the territory in mid-February. He sings loudly to proclaim ownership and he fights off other male chaffinches. You will rarely see more than one male chaffinch in the garden from now until after the breeding season. Each territory may cover several thousand square metres. Attracted by the male's song, the hen takes up residence early in March and, after six weeks of increasingly ardent courtship, she begins to build her nest in the fork of a tree or shrub. The male gives her no help and she takes about a week, using moss, grass, lichens, fine roots, feathers, and spider webs to make a neat cup.

Four or five eggs are laid early in May and the female incubates them herself for about 14 days. She leaves the nest to feed from time to time and the male often accompanies her, although he does not feed her. He does not come to the nest until the nestlings are several days old, but he then helps to feed them with caterpillars and he continues to do this until the young birds become independent about three weeks after leaving the nest. Only one brood is reared as a rule, although a second brood is occasionally produced in the south.

Ringing of chaffinches indicates that 90 per cent of British individuals stay within about 5km of their birthplaces. Many continental birds migrate, however, and large numbers invade Britain from northern Europe in the autumn. These immigrant birds are rather larger and paler than our resident chaffinches and they tend to form big flocks in the fields. Our resident birds remain close to their breeding territories in the winter and form only small groups. Barring accidents, the birds return to their original territories to breed in the spring, so the same pair could breed in your garden two, or even three years running.

Length: 15 cm
Voice: very variable, but commonest call is 'pink-pink'

The Bullfinch & Greenfinch

BULLFINCH & GREENFINCH

Pyrrhula pyrrhula & Carduelis chloris

THE greenfinch is a bird of dense undergrowth, thick hedges, and coniferous trees. It is common in well-established gardens, cemeteries, town parks, and woodlands. Being quite a sociable bird, it is often found in groups, even during the breeding season. It can be found over much of Europe, apart from the far north, in North Africa, and in Asia as far east as the Caspian Sea. The male, seen at the top of the plate, is easily recognised by the bright lemon flashes on his wings and at the base of the tail. He also has a yellowish rump. The female is an altogether duller bird and her yellow flashes are much less conspicuous.

The adults feed almost entirely on seeds, ranging from those of dandelions and charlock, through cereal grains, to the seeds of burdock, yew, and wild roses. Much of the food is collected on the ground, but the birds also spend a lot of time swaying on the plants as they rip off the seeds. Greenfinches are also regular visitors to the bird table in winter, being especially fond of peanuts.

Greenfinches are highly gregarious in winter and, although you may see only half a dozen or so in your garden at any one time, they form huge flocks in the fields, where food is abundant, and they also roost in large flocks. The birds gradually pair up in the winter flocks, through the stage of being 'good friends', and they begin to look for nest sites as the breeding season approaches. Each pair adopts a territory, but it is not particularly large, and the cock usually defends it simply by showing himself on a prominent tree or branch. He sings only if an intruder gets too close. Several pairs may nest close together in a loose kind of colony. The nest is built in a thick shrub. It is made of grass and moss, with a lining of fine roots and hair. Four to six eggs are laid from mid-April onwards and incubated for two weeks by the female. The young spend a further two weeks in the nest, being fed regurgitated seeds, insects, and spiders by both parents.

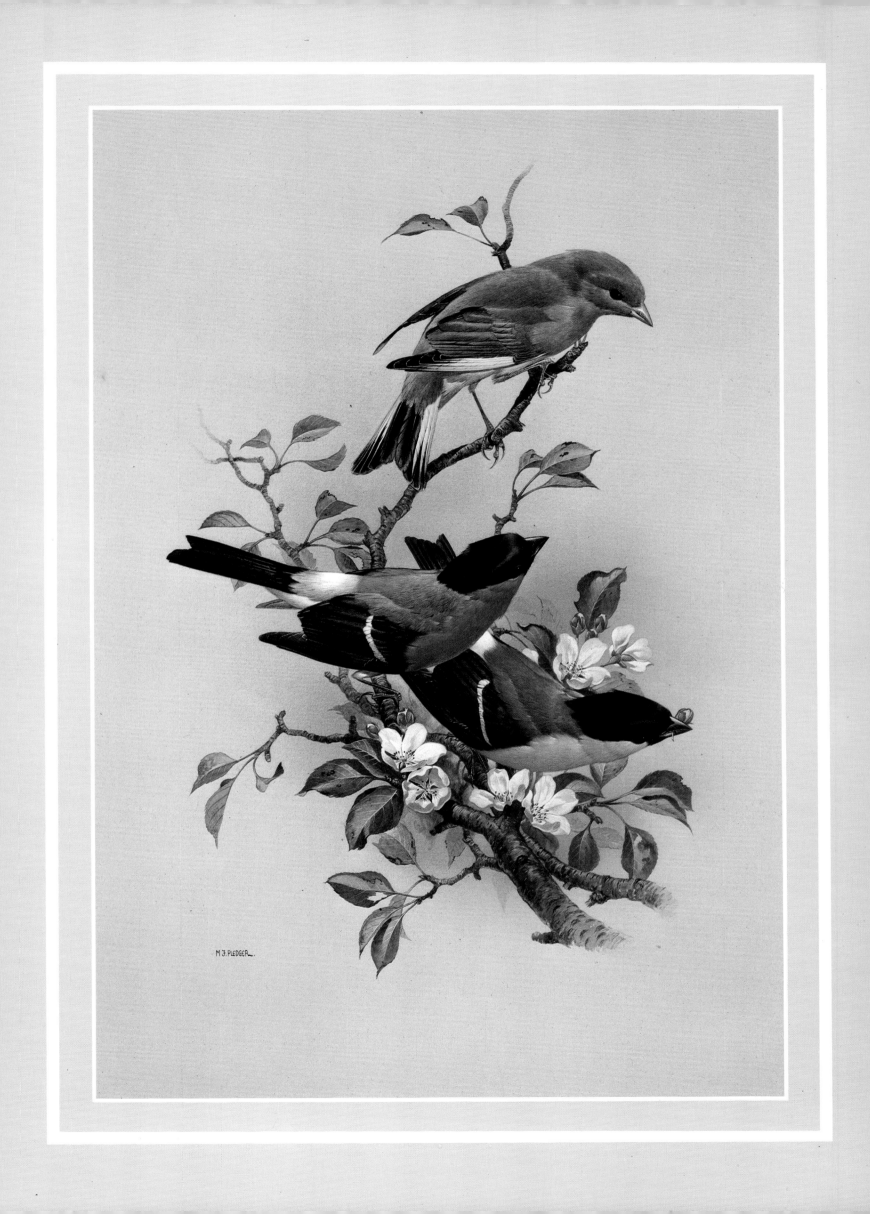

*T*HE bullfinch is a beautiful bird, but it is not a welcome visitor to the garden because of the great damage it does to the buds of fruit trees and bushes. For much of the year, it eats seeds from a wide variety of trees and other plants, but buds may form one third of its annual food intake. It can strip them from the branches at the rate of 30 per minute, peeling the outer scales off with the sharp edges of its beak and swallowing the rest. It is rarely seen on the ground.

Bullfinches mate for life and are almost always seen in pairs. The brightly coloured male is usually seen first, but his mate is unlikely to be far away. Several pairs may join up for the autumn and winter and tour the countryside, with no permanent roost. Breeding behaviour begins in April or May, with the cock leading his mate to several potential nest sites. Both often carry twigs in their beaks at this time, but the hen actually selects the site and builds the nest—usually fairly low down in a thick shrub. The nests are well spread out, but the birds do not show any real territorial behaviour and have no territorial song. The nest itself is made of fine twigs and moss, generally lined with fine roots and hair, and three to six eggs are laid early in May in southern areas. The female incubates them for two weeks, after which the chicks are fed with a mixture of seeds, insects, spiders, and small snails carried back in special pouches that develop on the floor of the parent's beaks at this time. There may be two or even three broods.

Bullfinches live in most parts of Europe, and right across north-central Asia to Japan. In many parts of the range they live in coniferous forests, but they are most abundant in the deciduous forests of Western Europe, and it is from here that they spread into our orchards. Hawthorn buds are one of their major foods in the wild, but gooseberries, pears, and plums suffer most on cultivated land.

Length: Greenfinch 14.5cm
Bullfinch 16cm
Voice: Greenfinch—most distinctive calls are 'chi-chi-chi-chi-chi' and 'dweeee-ee-ee-ee
Bullfinch—song very soft and rarely heard, but gives out a monotonous piping whistle

The Woodpigeon

WOODPIGEON

Columba palumbus

THE woodpigeon is primarily a winter visitor to our gardens, and even then it generally visits only the more exposed gardens. It is really quite a beautiful bird, but it is not a welcome visitor because of the destruction it causes in the cabbage patch. The bird breeds everywhere in Europe apart from the far north, and it extends through western Asia as far as the Himalayas. It prefers deciduous woodlands of oak and beech, but also lives in parks. It inhabits coniferous forests in some parts of its range, but it is then entirely dependent on agricultural land for feeding. In fact, the woodpigeon is closely linked with farming everywhere and always takes a high proportion of its food from the fields.

Woodpigeons are highly gregarious birds in the winter, roosting in vast flocks by night and feeding in the same great flocks in the fields by day. They depend very much on clover and other green crops for their winter food and spend about 95 per cent of the daylight hours feeding. Clover leaf fragments, snapped up at rates as high as 100 per minute, may account for about 95 per cent of the food in many places, and the crop may be jammed solid with them when the bird returns to roost and to digest its food at night. Many other foods are eaten, however, including cereal grain and leaves, peas, beans, and brassicas. Tree buds and flowers are eaten in the spring, and their fruits are taken in the autumn. Acorns are much appreciated, and one bird was found to have 36 of them in its crop when examined. Another had eaten 190 beech nuts. Little animal food is eaten, although some slugs and snails, woodlice, and earthworms are taken in the summer, especially when young are being reared. The birds also drink a good deal, particularly when feeding on grain.

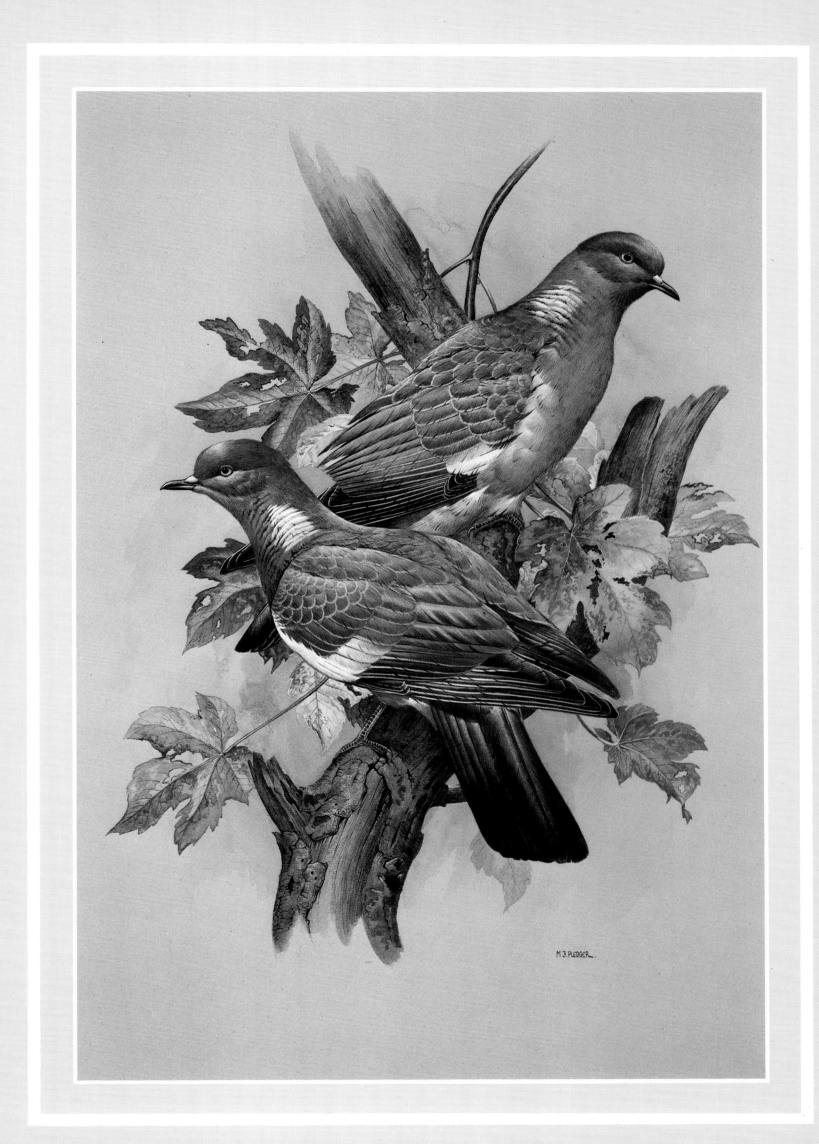

M J PLEDGER

THE first signs of territorial behaviour can be seen around the end of February, when some males leave the roosts early in the morning and station themselves in their favourite trees. They give the familiar *coo-coo-coo-co-co* call to indicate ownership. They go off to feed with the other birds later in the morning, but return to their territories to stand guard for a while before retiring to the roost. More and more time is spent in the territories as the year goes on, and the birds eventually sleep there. The noisy, wing-clapping flight reinforces the cooing as an indication of occupation.

Females are wooed with a lot of bowing and cooing, and if a pair accept each other they indulge in a great deal of billing and cooing throughout the summer. A nest site is selected—usually in a tree, but sometimes in a hedgerow or even among bracken on the ground—and a flimsy, but firm platform of twigs is built by both birds. Some egg-laying takes place from April onwards, but early clutches are rarely successful and the majority of birds refrain from breeding until July. About 70 per cent of the year's young woodpigeons are reared in July and August, for this is when ripe grain is most abundant.

Two eggs are laid and they are incubated by both sexes, although the male probably sits for no more than six hours out of the twenty four. Incubation lasts for seventeen days, and the young birds stay in the nest for three weeks. They can fly when five weeks old. For the first three days of their lives, the young receive almost nothing but pigeon milk, a nutritious fluid secreted by the crop of both parents. Ripe cereal grains then become their major food, with various weed seeds filling in if the cereals are not ripe. Although the adult birds defend the territory around their nests, they remain sociable away from their territories and continue to gather food in flocks. The young birds leave their nests in August and September and continue to feed on grain in the stubble fields, but they turn to green food as the seed crop becomes exhausted.

Length: 40cm
Sexes similar
Voice: Variations on 'coo-coo-coo-co-co'—quite soft and repeated many times

The
Wren

WREN

Troglodytes troglodytes

THE wren is one of the smallest of our garden birds, with a weight of less than 10 grams. Its small size, combined with its all-brown colour and its characteristic cocked-tail attitude, make it easily identifiable at all times of the year. The bird occurs almost throughout Europe, in North Africa, in the temperate regions of Asia, and in various parts of North America, and it probably occupies more habitats than any other species. Only the highest peaks and the densest urban developments are without this active little bird.

Wrens like the cover of thick hedges and undergrowth, and favour houses with plenty of creepers growing on them. Dilapidated out-buildings are other favourite haunts. The birds tend to stay quite close to the ground, and because of their habit of scuttling about through the undergrowth they are often mistaken for mice. They are very agile on their feet and climb tree trunks almost as well as a tree-creeper. The birds feed almost entirely on insects, including caterpillars, beetles, moths, and flies. These are deftly plucked from the vegetation with the slender, tweezer-like beak. Spiders are also eaten, and the birds search bark crevices for insect eggs in summer and winter alike. With their large surface to volume ratio, the wrens need a great deal of food to keep themselves warm, and their populations fall dramatically in harsh winters. Although the birds are solitary for much of the year, large numbers often roost together to keep warm in the winter. More than sixty have been known to roost in one small nest box. Many wrens move south for the winter.

The male wren seems to hold a territory throughout the year, and he defends it with a shrill, warbling song which is extraordinarily loud for such a small bird. It can be heard on any day of the year, but peak performance is reached in the breeding season between March and June. The bird also has a very loud call—a prolonged *tic-tic-tic-tic*, which is produced anywhere and at any time and which may go on for a minute or more.

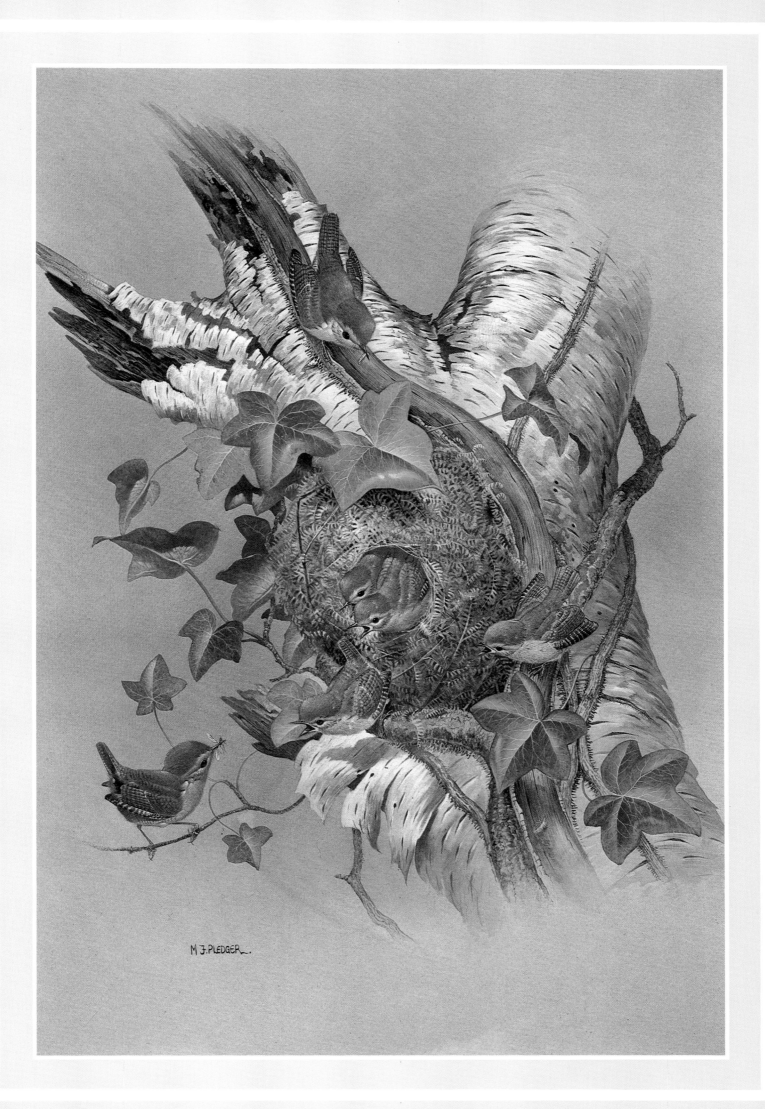

M.J.PLEDGER.

THE breeding season starts in April, when the male wren begins to build several nests in his territory. Each is a stout, domed structure with a rounded entrance on one side. It is made largely of moss, leaves, and other soft plant materials and it usually blends in beautifully with its surroundings. It is sometimes built in a hedge, but is generally placed against a firm support, such as a wall or a tree trunk, and whenever possible it is built into some kind of crevice or cavity. Ivy-covered walls and tree trunks are particularly favoured, and the nest may be anywhere from ground level to about three metres up.

Having built one or more nests, the male begins his courting. He attracts a female with a rather soft version of his territorial song and invites her to inspect his handiwork. If she is sufficiently impressed by a nest, she will take up residence and complete the building by lining it with feathers. After mating, she lays five or six eggs and incubates them alone for about two weeks. The male takes no interest in her at this time, for he is busy trying to instal more females in other nests that he may have built around his territory. He may end up with three wives, and he courageously defends all their nests. As each family of chicks hatches, the male goes back to help the mother to feed them, and he carries on feeding them when they begin to leave the nest, at which time you may see the whole family hopping about on the vegetation, as shown on the plate.

Length: 9.5cm
Sexes similar
Voice: A shrill warble, used for various purposes, and a loud 'tic-tic-tic-tic'

The
Common Jay

COMMON JAY

Garrulus glandarius

THE Eurasian jay is one of the most colourful members of the crow family. It occurs in most parts of Europe and in much of Asia, and it is essentially a woodland bird. It is especially fond of acorns, and is therefore particularly common in oak woods and mixed deciduous woods, but it also occurs in coniferous woods and it frequently comes into well-wooded gardens, orchards, and town parks. Although a rather variable bird, it can always be recognised by the blue and black feathers on the front edges of the wings.

Jays are omnivorous birds, with insects, spiders, earthworms, slugs, fruits, and seeds all featuring prominently in their diet. Significant numbers of the eggs and nestlings of other birds are taken in the spring, and the jay is generally regarded as the worst egg-thief in the woodlands. It watches the other birds building their nests or flying in with food, and it follows them to find the exact whereabouts of the nests. It moves in to plunder the nests later, often ripping them to pieces as well as taking their contents. Acorns are a favourite food in late summer and autumn, and in a good year the birds collect and bury them for later use. Some observations indicate that a single jay can bury more than 150 acorns in a day. It carries up to six at a time, holding one in its beak and the others in a pouch in its throat, and it buries them under moss and dead leaves. The acorns are dug up again and eaten in the winter and spring, and the jays apparently have very good memories for where they buried their stores. They can find the acorns even when they are covered with snow, but not every buried acorn is recovered, and the jays thus play quite an important part in the regeneration of oak woods. Wild cherry seeds are distributed in a similar way, but the jays' activities are not so welcome when they turn their attention to our orchards and strip cultivated cherries and other fruits from the trees.

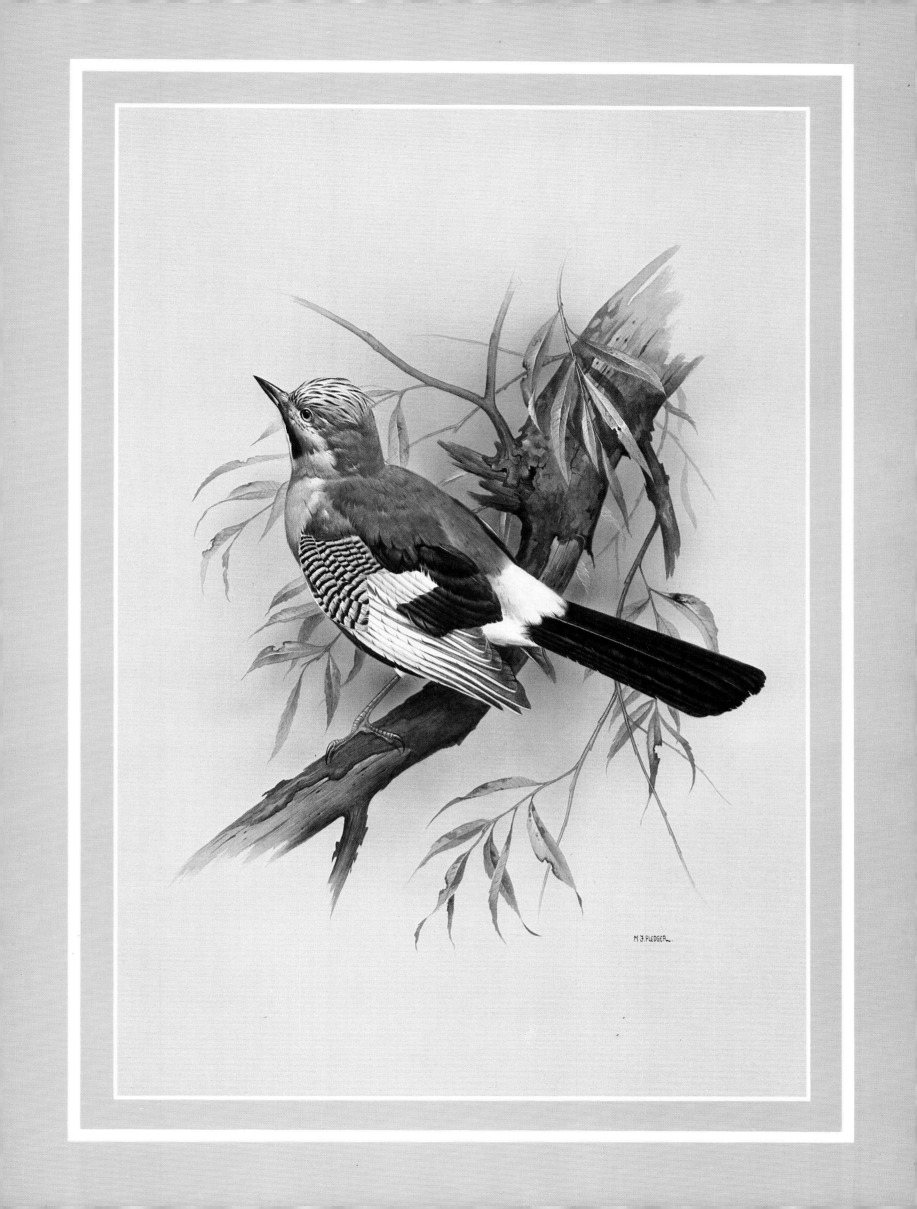

M.J. PLEDGER

*T*HE jay is one of a number of common birds—thrushes and starlings are other well known ones—that indulge in the strange practice of 'anting'. The birds sprawl out on or around ant-hills and, by scraping their wings on the ground, they positively encourage the ants to invade their feathers and discharge formic acid amongst them. This odd behaviour is believed to help maintain the plumage in good condition and to rid the feathers of lice and other parasites.

Jays are basically rather shy birds and they readily fly off when disturbed, uttering their harsh warning call of *skark-skark-skark*. They have no real song, but they are great mimics and imitate to perfection the calls of blackbirds, crows, and even owls. They can also imitate mechanical noises and human voices.

The birds begin to breed in April, after what appears to be a communal courtship in which many birds congregate in the trees and emit soft warbling and crooning noises. They gradually pair off and select nest sites. These are generally in the forks of trees and usually between two and six metres above the ground. Both birds build the nest with twigs and mud, and line it neatly with fine roots and hair. Five to seven eggs are laid and incubated by both sexes for about 16 days. The young are fed by both parents, their main foods being caterpillars collected from the trees. They are able to leave the nest when they are about three weeks old.

Length: 34cm
Sexes similar
Voice: Commonest call is harsh 'skark-skark-skark'

The Starling

STARLING

Sturnus vulgaris

THE starling is one of the world's commones birds. It is a native of Eurasia, where it exists in almost every kind of habitat except the more extensive forests and the higher hills. It has also been introduced into North America, New Zealand, and Australia in all of which it has established itself exceptionally well and become extremely numerous. It is one of the most numerous breeding birds in Britain, and during the winter, when as many as 35 million starlings arrive from northern Europe, it may well be the commonest of all British birds.

It is mainly during the winter that we see the starlings in our gardens. They occur in small groups and strut about in a very assertive manner, often 'bullying' smaller birds and driving them away from the bird table. They eat almost anything, and when they have finished on the bird table they dig their long beaks into the lawn in search of leatherjackets and other insects. Fruit is a favourite food, and the birds make short work of any fallen apples left in the garden.

In the middle of a winter afternoon the starlings from a small area—perhaps a few neighbouring gardens or a whole village—gather in a prominent tree, or perhaps a hedge, and indulge in a great deal of chattering for perhaps an hour. They then fly off together to the nocturnal roost, where they are joined by thousands of other starlings which have spent the day feeding in the fields. A large roost may contain well over 50,000 starlings, drawn from an area of more than 3,000 square kilometres, and it is a very noisy affair until the birds finally settle down to sleep. The roosts may be in small stretches of woodland, in reed beds, or on town buildings. When roosting in towns, the birds make a real mess on the walls and pavements with their droppings. Small roosts sometimes occur on single trees in towns, and again the pavements suffer. The trees are also damaged by the accumulation of droppings on their branches.

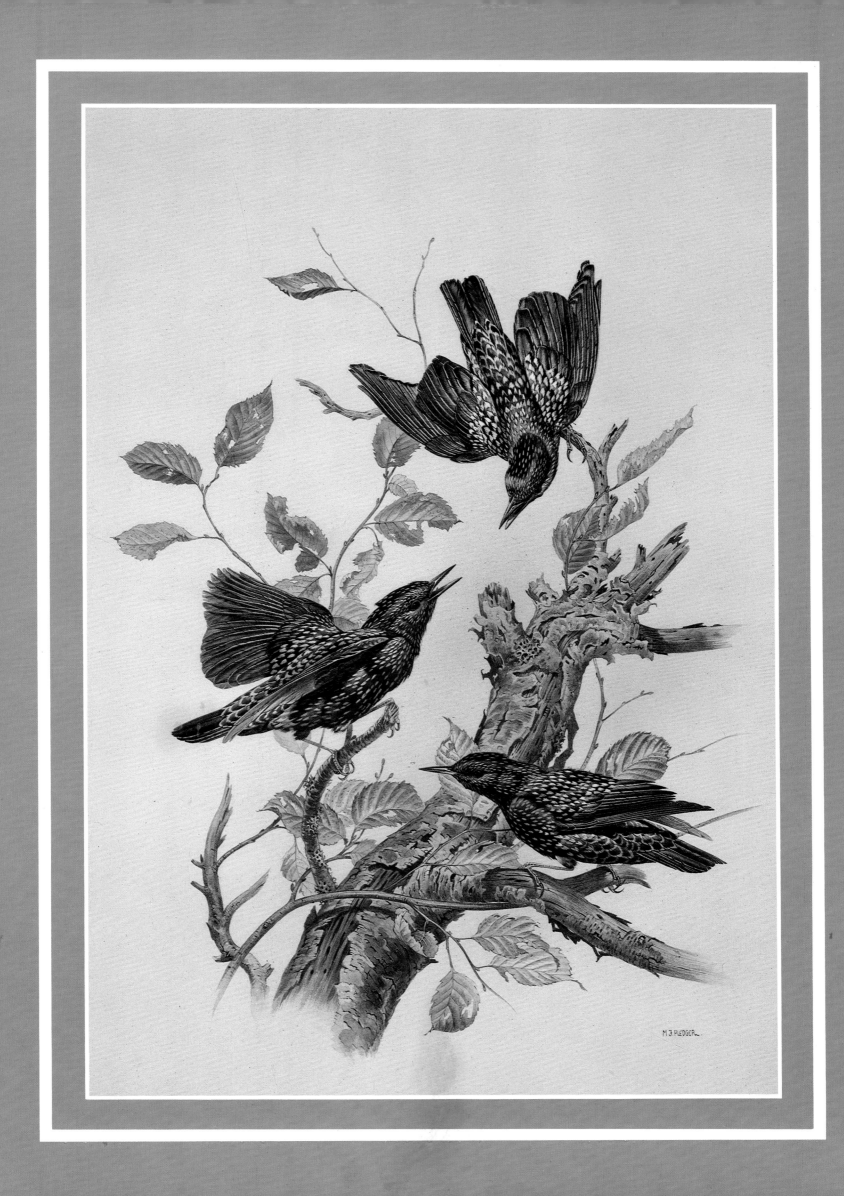

THE starling has no real song, but it makes a tremendous variety of warbling and chuckling noises. One of its commonest calls is a rapid clicking noise, often delivered from the top of a tree or a chimney stack. The bird also gives out long whistles, and it can produce some remarkably good imitations of other birds.

Breeding begins in April, when the birds spread themselves out over the countryside and select their nest sites. The nests are usually fairly well separated, but there may be local aggregations. The nest is generally built in a hole in a tree or a building, in a rock crevice, or among dense ivy or other creeper. The male begins the nest with a rather untidy pile of twigs and other plant material, and the female finishes it off with a lining of moss, feathers, and wool. She then lays between four and seven eggs, and when there are several nests in close proximity all the eggs in the 'colony' are laid within a few days of each other. The female does most of the incubation, but the male gives a hand for a few hours during the day. Some females have a cuckoo-like habit of laying their eggs in the nests of other starlings and throwing out some of the original eggs to keep the numbers right.

The eggs hatch after about two weeks, and both parents feed the nestlings for about three weeks in the nest and for a few more days after they leave. A pair may bring their young as many as 27,000 insects in this time, many of them leatherjackets. There is sometimes a second brood. After leaving the nest, large numbers of youngsters band together and, together with the adults, they scour the land for food. They are particularly damaging to cherries and other fruit in mid-summer. Communal roosting begins right away, but summer roosts are smaller than winter ones.

Many people regard starlings as dull, black birds, but in fact they are beautifully coloured. The feathers have iridescent green and purple sheens in summer, while in winter they are spangled with pale spots as shown in the plate. The beak is dark in winter, but yellow in summer.

Length: 21cm
Sexes similar
Voice: Very variable; commonest call a clicking chatter

The
Nuthatch

NUTHATCH

Sitta europaea

THE European nuthatch is a sprightly little bird found over most of Europe and large areas of Asia. It extends as far north as southern Scandinavia, although it is absent from northern Britain. It is essentially a bird of the deciduous woodlands, but it readily settles in parks, orchards, and well-timbered gardens and it can easily be attracted to the bird table.

Nuthatches obtain a certain amount of their food by searching tree trunks for insects, and they display truly amazing agility while they are hunting in the bark crevices. Unlike the woodpeckers and tree-creepers, the nuthatches do not use the tail as a support when climbing. They rely entirely on their long toes to give them sufficient purchase on the bark, and this means that they can run headfirst down the trunks just as easily as they can run up them.

The birds are primarily seed-eaters, however, and they are more than willing to display their agility on bags or strings of nuts hung from the bird table. All kinds of seeds are acceptable to the nuthatches, but the birds are most famous for their technique of opening hazel nuts— their most important food during the autumn months. The nuts are picked up in the powerful, pointed beak and wedged firmly into bark crevices, usually within a couple of metres of the ground. Oak trees are most commonly selected because their bark has more suitable crevices than any other. With the nut firmly fixed, the bird begins to hammer it vigorously with its beak and it soon makes a jagged hole through which it can extract the kernel. The broken shell generally remains in the bark crevice and is a good indication that nuthatches are about. It also shows just why the bird got its original name of nut-hack. Wedging a few hazel nuts into the bark of your garden trees is a good way to attract nuthatches if there are any in the vicinity. Acorns and beech nuts are regularly hacked open, either on the tree or on the ground, and the birds also peck into oak apples and marble galls to get at the insects inside.

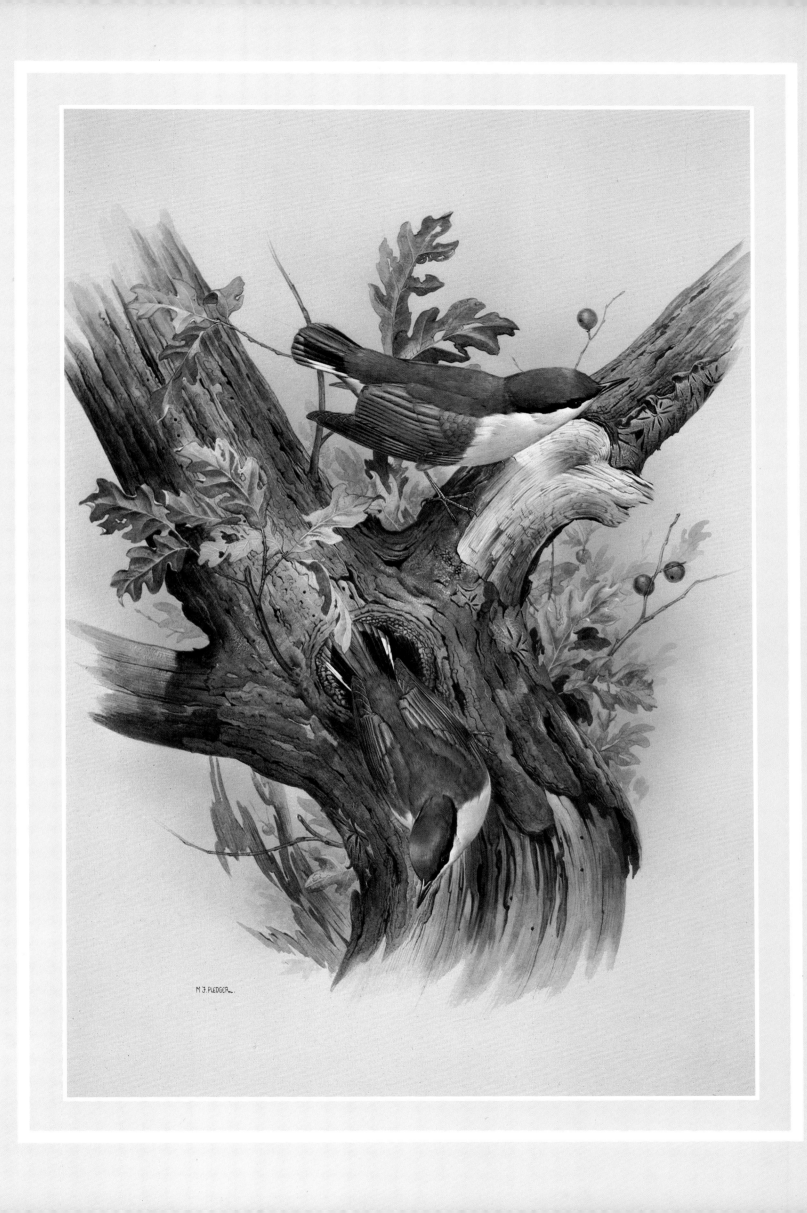

NUTHATCHES have a wide vocabulary of loud, piping calls with a distinct metallic ring to them. The commonest is a rather monotonous *chwit-chwit-chwit*, which is repeated over and over again and which advertises the birds' presence even when they are well out of sight in the tree-tops.

Breeding begins in late April or May, and the nest is always built in some kind of hole—usually in a tree trunk, but sometimes in a wall. Nest-boxes are readily accepted. If the entrance is too wide, the birds plaster it with mud to reduce the size, and the female then gets on with the job of building the nest inside with leaves, grass, and slivers of bark. The cock bird occasionally helps with the building work, but he plays no part in the incubation of the five to nine eggs. He feeds the female during the 16 or so days that she is sitting on the eggs, and then both parents feed the young with caterpillars and other insects and with spiders. The young leave the nest when they are between three and four weeks old. The birds do not migrate.

Length: 14cm

Sexes similar

Voice: A variety of metallic piping calls, commonest of which is 'chwit-chwit-chwit'

The Green & Greater Spotted Woodpecker

GREEN & GREATER SPOTTED WOODPECKER

Pica viridis & Dendrocopos major

THE woodpeckers are basically woodland birds that spend the bulk of their lives in the trees. They are primarily insect-eaters, and they use their long, straight beaks to probe for beetles and grubs in rotten wood and under bark. The immensely long tongue can be thrust deep into holes to collect the insects. When searching for food in this way, the woodpeckers spiral their way up a tree trunk and then fly down to the base of the next tree to start again. They support themselves with their stiff, spreading tail feathers, which are clearly seen in the plate, and get extra support from the arrangement of the toes, with two pointing forwards and two pointing backwards. Seeds, particularly those of conifers, are also eaten by woodpeckers. They wedge the cones into bark crevices and tear them to pieces in order to get at the seeds.

Three species of woodpecker occur in Britain, and all are frequent visitors to mature gardens. They will also breed in orchards and well-timbered parks. The three species are the green and the greater spotted woodpeckers, which are pictured on the plate, and the lesser spotted woodpecker. With a length of only 14.5cm, the latter is the smallest of the European woodpeckers. It is easily recognised by the black and white stripes running across the wings and back.

The green woodpecker is also called the yaffle because of its loud, laughing call which is uttered in flight. The male is seen at the top of the plate. The female is similar, but lacks the red patch under the eye. Unlike the other species, the green woodpecker obtains a lot of its food on the ground. It is very fond of ants, and can often be seen delving into ant hills in woodland clearings and in fields bordering the woods.

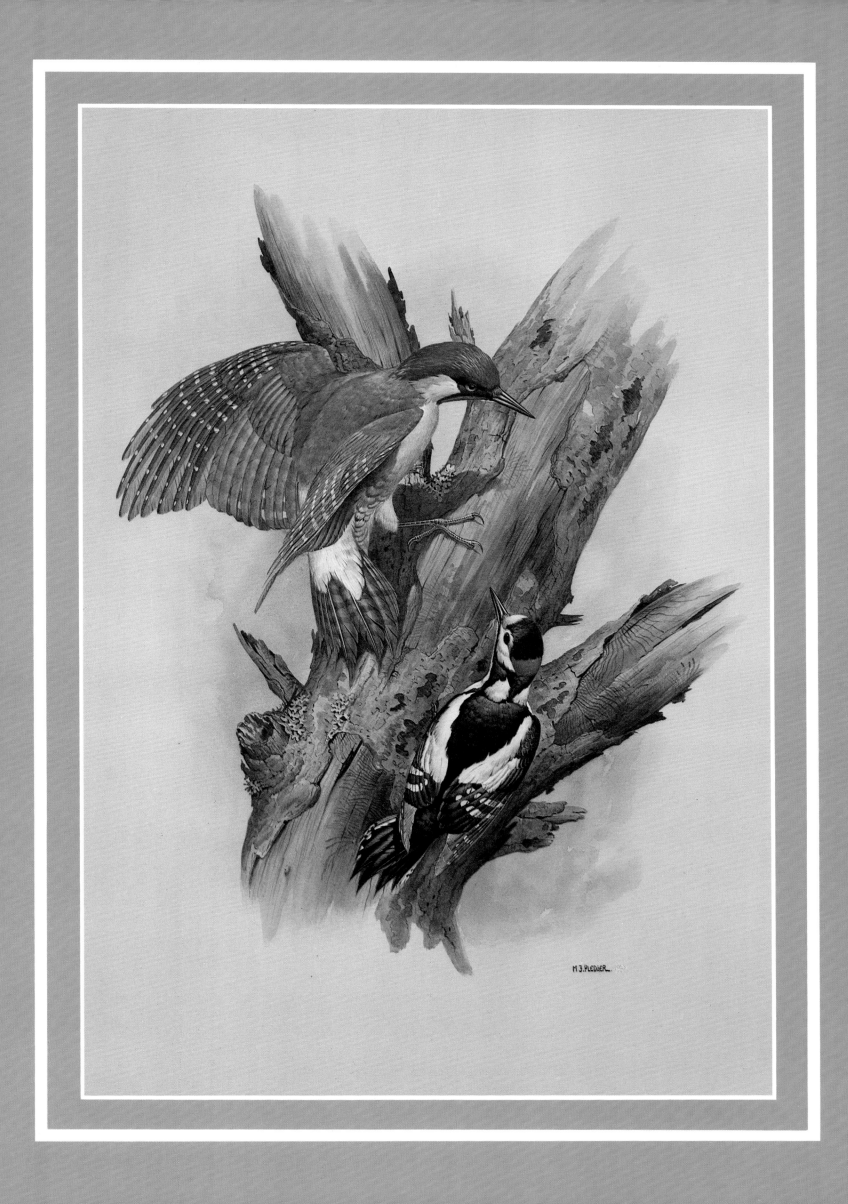

THE green woodpecker also visits lawns and collects insects by plunging its beak into the grass. The greater spotted woodpecker is more likely to be seen in coniferous forests than the green woodpecker, and this is the species most likely to attack cones, but it is equally common in deciduous woodlands. Its commonest call is *chick-chick-chick*, but it also has a harsh, churring call when excited. The greater spotted woodpecker is much more widely distributed than the green woodpecker: it extends north to the tree line in Europe and Asia, while the green species reaches only to southern Scandinavia and is absent from northern Scotland. Neither species occurs in Ireland. The male greater spotted woodpecker is pictured. The female is similar, but she lacks the red at the back of the head.

The greater spotted woodpecker 'drums' a good deal by hammering its beak against dead trunks and branches, or even telegraph poles. The sound carries a long way and probably serves to indicate ownership of a territory. Green woodpeckers drum only occasionally, and always much less noisily.

Breeding begins in late April or May, with male and female working together to excavate a nesting chamber in a tree trunk. They usually choose dead, but fairly sound wood, and the entrance hole leads into an elongated cavity up to 40cm deep and 15cm across. There are slight differences in design between the two species. No nesting material is collected, and the eggs—usually between four and seven—are laid on the floor of the cavity. Incubation is by both sexes, although the female greater spotted woodpecker does more than her share. Her eggs hatch in about 16 days, while those of the green woodpecker take a day or two longer. The latter species feeds its young with regurgitated food in a semi-liquid condition, but the greater spotted woodpecker brings insects in its beak. The young of both species leave the nest when they are about three weeks old.

Length: Green 32cm
Greater spotted 23cm
Voice: Green—A cackling yelp and, in spring a ringing 'plew-plew-plew'
Greater spotted—Varied chattering and churring, and a sharp 'chick-chick-chick'

The Goldcrest

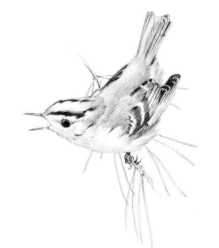

GOLDCREST

Regulus regulus

*T*HE goldcrest shares with the closely related fire-crest the distinction of being Europe's smallest bird. It is a woodland species, especially fond of conifers and yews, but it is not an uncommon visitor to mature gardens containing ornamental evergreens, especially if they are close to coniferous woods or plantations. It is also quite frequent in cemeteries with the traditional yew trees. The bird is less choosey about its winter quarters, however, and nomadic bands often wander through deciduous woodlands and even areas of scrub well away from any kind of woodland. The goldcrest occurs over most of Europe and much of northern Asia, and it is one of the commonest birds in the Scottish spruce plantations, although it is by no means the most frequently seen.

Goldcrests are insect-eating birds, feeding on aphids, caterpillars, and many other small insects in the trees. They also eat insect eggs, particularly in the winter, and large numbers of spiders. Every minute of daylight has to be used for feeding during the winter for, like the wrens, the goldcrests find it difficult to keep warm. Large numbers die during very cold winters.

The birds can be heard at almost any time of the year. Their song is a very high-pitched *cedar-cedar-cedar-stitchy-see-pee*, and there is also a thin call of *zi-zi-zi-zi-zi*, which is easily confused with the calls of tits and tree-creepers. The calls are often uttered when the birds are feeding high in the trees and out of sight.

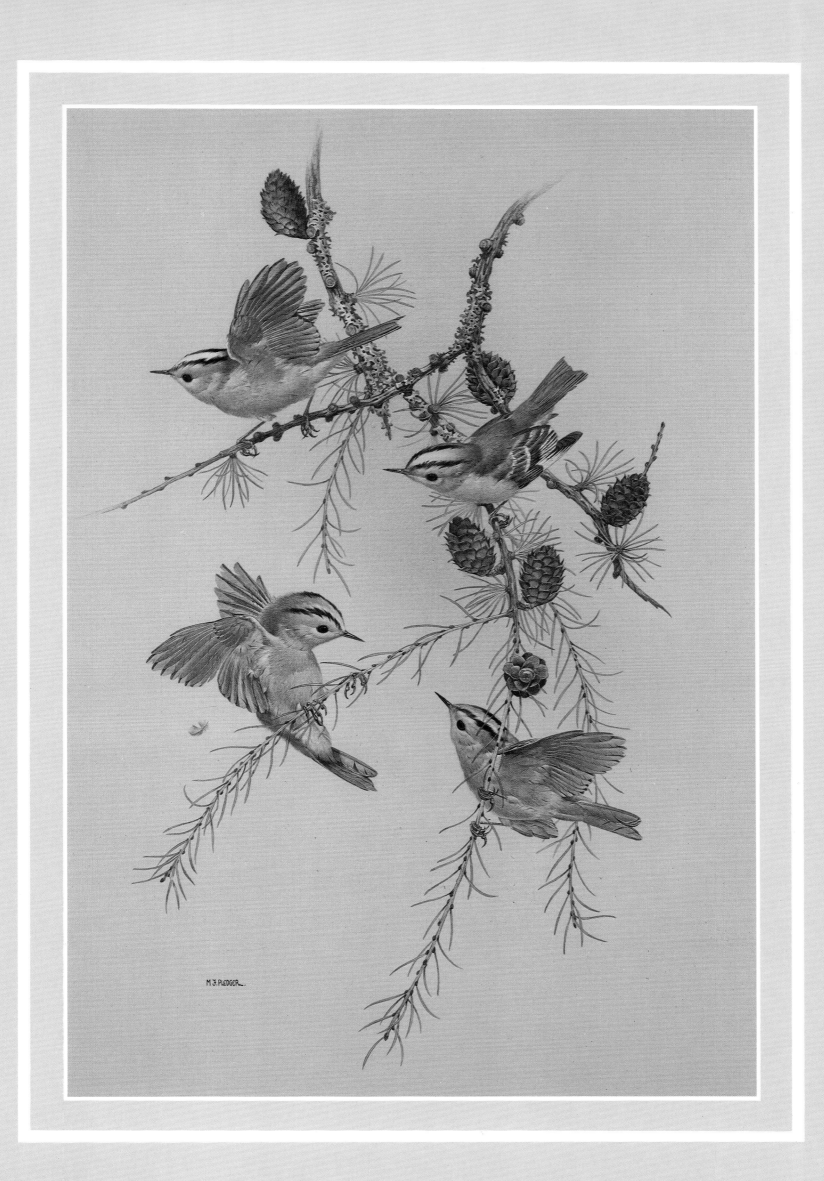

M.J.PLEDGER

MALE goldcrests, two of which can be seen quarrelling at the bottom of the plate, have crests of bright orange feathers. The females, seen at the top of the plate, have paler yellow crests, but the two sexes are otherwise very similar.

Breeding begins late in April, when the birds pair up and select their nest sites. The nest is nearly always built in a conifer, and it is commonly more than 15 metres above the ground, although it is occasionally built in some other evergreen tree or shrub. It is suspended from a branch, often towards the tip where it is concealed by the dense foliage. Both sexes are involved in building the nest which, when complete, is in the form of a deep cup with a very small entrance just where it joins the branch. It is made largely from moss and lichen, and lined with feathers. Spider silk also plays an important role in binding the components together and holding the whole construction firmly on the branch. Between seven and twelve eggs are laid and incubated by the female alone for between 14 and 17 days. Both parents then feed the youngsters in the nest for about three weeks. There is sometimes a second brood.

The firecrest, which is much rarer in Britain than the goldcrest and is found mainly in the more southerly parts of England, can be distinguished from its relative by the prominent black stripe that runs through its eye. It is much less strongly tied to conifers than the goldcrest.

Length: 9cm
Voice: Very high-pitched song 'cedar-cedar-cedar-stitchy-see-pee'. Thin call of zi-zi-zi-zi-zi

The
Song Thrush

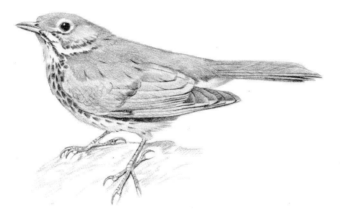

SONG THRUSH

Turdus philomelos

THE song thrush, still sometimes known by its old-fashioned name of throstle, is among the ten most common birds of Britain. It is rare in upland regions, but elsewhere it can be found wherever there are a few bushes or other cover for nesting. The bird is most abundant in the woodlands, but it is also very common in hedgerows, parks, and orchards, and it is a regular inhabitant of the garden.

Song thrushes occur in most parts of Europe and central Asia during the summer, but there are great southward and westward migrations in the autumn, leaving large areas of north and central Europe devoid of song thrushes for the winter. Many birds reared in Britain spend the winter in Ireland. Small flocks of perhaps a dozen or twenty birds can be seen in the fields in the winter, but the song thrush is much less sociable than the blackbird and its other relatives and, except when the young are being taught to feed, it is rare to see more than one or two birds in the garden at any one time. The bird is strongly territorial, and those individuals that remain with us throughout the year begin to establish their territories in December or even earlier. Both sexes adopt territories, and the far-carrying song, usually delivered from high in a tree, is at full strength from then until July. The song is very clear and musical and made up of a number of distinct phrases each of which is usually repeated. Song thrushes are also good mimics and frequently copy the songs of blackbirds and nightingales. The most common call is a soft *sip-sip-sip*, and there is also a rather loud and high-pitched *cheek-cheek* which is uttered as an alarm call.

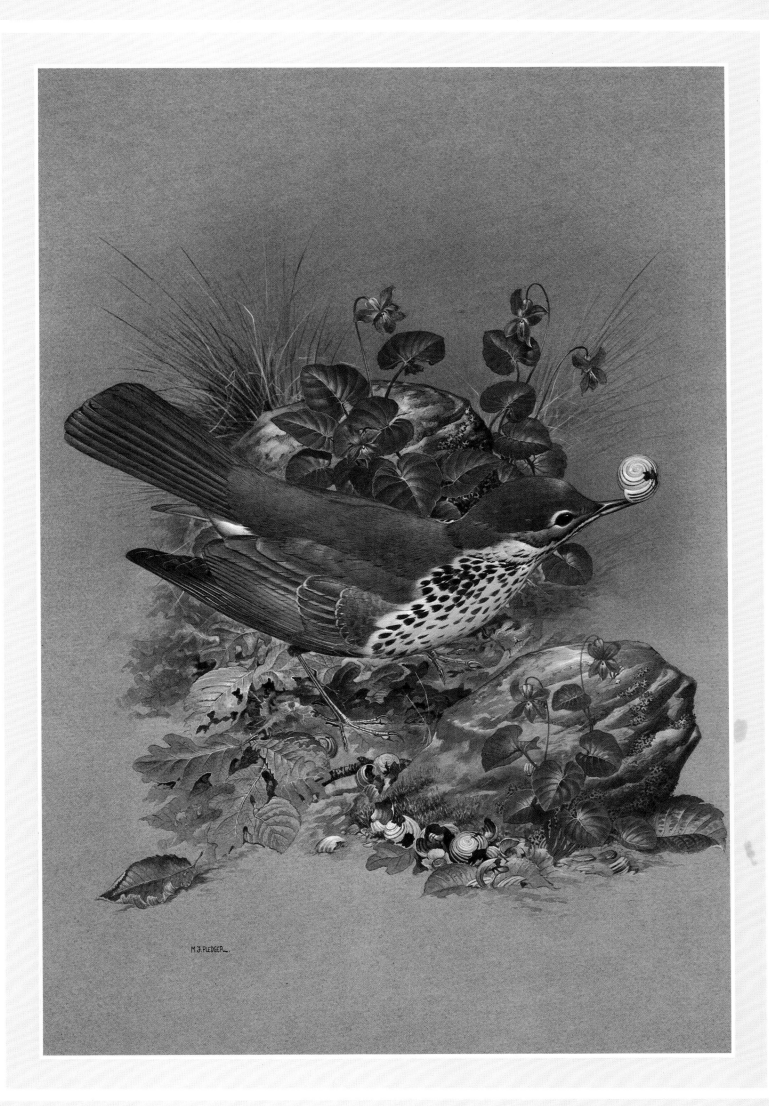

M.J.PLEDGER

THE song thrush feeds primarily on insects, spiders, and other small animals. It is often seen hopping over the lawn and stopping here and there to cock its head on one side to listen for worms tunnelling in the soil. When it hears something, the stout beak is plunged into the ground, and it often comes out dragging a reluctant worm. But the song thrush's favourite food is snails. The shells are picked up in the beak and carried to a particular stone, known as the thrush's anvil, on which they are hammered until they break open and allow the thrush to get at the soft body inside. Anyone with a rockery or even a concrete path in the garden will have heard the intermittent, loud tapping of the thrush bringing the snail down on the anvil as shown in the plate. The ground around the anvil soon becomes littered with broken shells. Berries and other fruits are eaten in season, and the thrush may be a nuisance to soft-fruit growers, although the damage done to the fruit is certainly offset by the beneficial work done in eating pests.

Courtship begins early in the spring, and a nest site is generally selected fairly low down in a bush or a hedge. The female builds alone, producing a fairly solid cup of woven grass with a smooth lining of mud. She then lays four or five beautiful blue eggs with large black spots and incubates them herself for about two weeks. Both parents then bring caterpillars and other insects, worms, slugs, and snails to feed the young. The latter leave the nest after about 14 days, but they stay with their parents for another week or more, during which time they may be led around the garden and shown how to break open snail shells. There are usually two broods, sometimes even three or four.

The song thrush is easily confused with the mistle thrush, but the latter is slightly larger and it has a much greyer back. It also lacks the fawn tinge on the breast

Length: 23cm

Sexes similar

Voice: A great variety of loud, pure notes. Commonest call is 'sip-sip-sip'

The Tawny Owl

TAWNY OWL

Strix aluco

THE tawny owl is one of the commonest of the European owls. It is absent from Ireland, but it is found nearly everywhere else in Europe and also over a large area of Asia, including the Himalayas. The bird occurs in almost any habitat with large trees, including parks and even tree-lined streets in towns, but it is most common in deciduous woodlands.

Like most other owls, the tawny owl is mainly nocturnal, although it often flies at dusk. Its sharp call of *kee-wik* is regularly heard as the bird hunts over its territory, and its other common call is the hoot—a long and tremulous *too-woo-woo-woo-woo*. These calls can be heard throughout the year, but are most frequent between January and June. The tawny owl spends the daytime roosting in a tree, usually hunched up close to the trunk and very difficult to see from the ground, but its presence is often revealed by numerous small birds which gather around it and call noisily. This behaviour is known as mobbing, and it often drives the owl away for a time. It is also possible to detect roosting owls by looking for pellets under likely trees. The pellets are greyish objects, up to the size of a thumb, and they consist of the indigestible fur and bones of the owl's prey. The owl usually coughs up two pellets each day, and it is possible to see exactly what the bird has been eating by pulling the pellets to pieces and examining the bones.

Tawny owls take a wide variety of prey, ranging from beetles and other insects, through frogs and fish, to rabbits and chickens, but the great bulk of their food consists of mice and voles. Tawny owls living in towns feed largely on house sparrows, which they catch at dusk, just before the sparrows settle down for the night. Other prey is usually taken in the dark with the aid of the owl's incredibly good eyesight and hearing. The bird can see a mouse moving on the ground even on the darkest night, and it can also hear the slightest rustle. Its flight feathers have very soft edges which eliminate flight noise, and the owl can thus hear its prey even while flying.

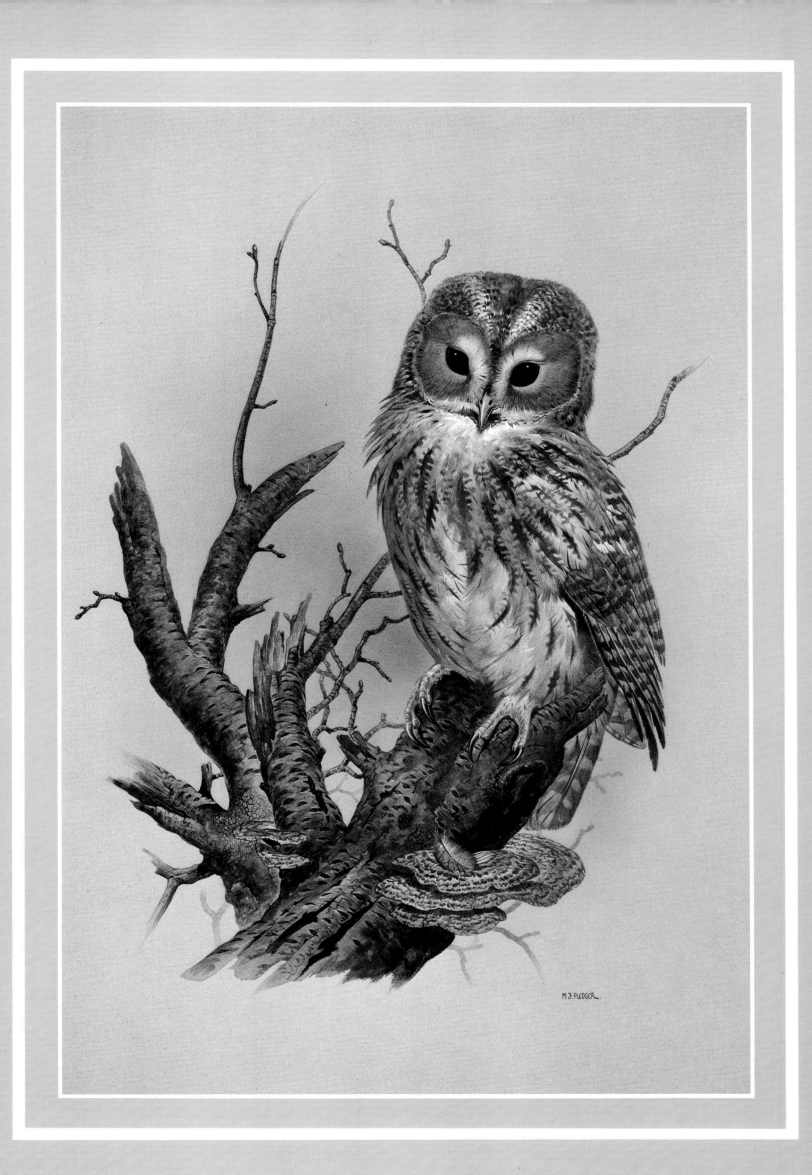

M.J.PLEDGER

*E*QUALLY important, the prey cannot hear the owl swooping down. The owl swoops down head first to start with, but at the last moment it thrusts its feet forward and snatches its prey with its formidable talons, which are well seen in the plate. The prey is generally killed outright as the talons sink home. Small prey is swallowed whole, but larger animals are torn to pieces with the great hooked beak, most of which is concealed among the feathers.

The birds begin breeding early in the spring, and usually select holes in trees for nesting. They sometimes use old buildings, and it is possible to attract the birds to large trees in the garden by providing them with wooden boxes securely fixed to the branches. A rectangular box about 75cm long and 20cm across is ideal It should be open at one end and fixed underneath a stout branch. The nest is not lined, and the female lays between two and six eggs as a rule. She incubates them alone for about a month, and then broods the chicks for a further three weeks. The male does all the hunting during this time, bringing food to the nest and then calling the female to come and collect it. Both parents hunt when the chicks are three weeks old, and the fluffy grey chicks leave the nest when they are about five weeks old. They gradually venture further from the nest, and then begin to look for territories for themselves. The birds are very attached to their territories and rarely leave them even when food is scarce, but few chicks are reared in times of food shortage.

Length: 38cm
Sexes similar
Voice: Hunting call is 'kee-wik', while other main call is 'too-woo-woo-woo'; no real song

The
Blackbird

BLACKBIRD

Turdus merula

THE European blackbird is now thought to be the commonest song bird in the British Isles. It occurs in a very wide range of habitats, from its native woodlands to towns and open moorlands. It is extremely common in both town and country gardens, and is second only to the house sparrow in London's parks. It is absent only from the most exposed habitats on the hills and coasts. It breeds in all parts of Europe apart from the far north, as well as in North Africa and in a broad belt across central Asia to China.

The male blackbird is easily identified by its glossy black plumage and yellow beak, but the female, seen at the top of the plate, is brown and thrush-like. Albino birds occur occasionally, and it is quite common to see blackbirds with white collars or other white patches on the head and neck. Blackbirds can regularly be seen patrolling the lawn, sometimes running and sometimes hopping, but always stopping at intervals to cock the head on one side to listen for earthworms or other creatures under the ground. The birds also have a very characteristic habit of cocking their tails almost vertically when they land.

Blackbirds are omnivorous creatures, but their main foods are fruits and insects and other small animals. A great deal of the food is collected on the ground, especially during the winter months, when the birds search noisily through the dead leaves for beetles and other juicy morsels.

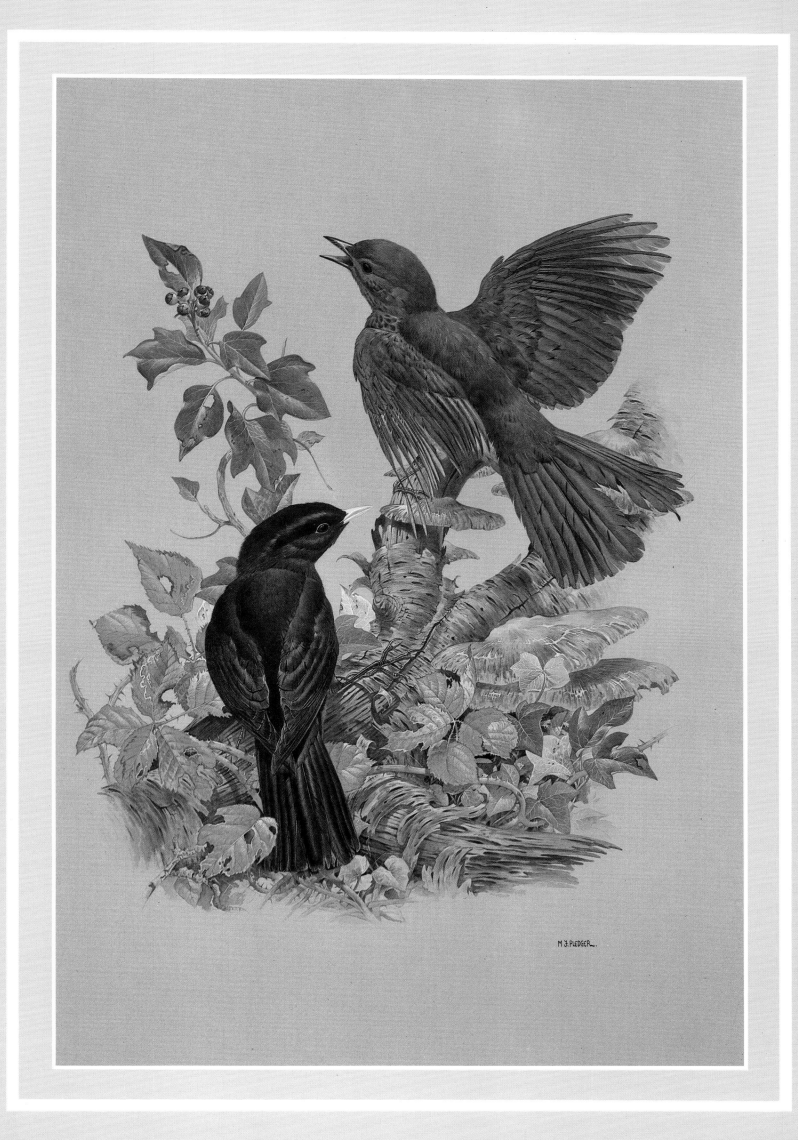

RASPBERRIES, currants, and other soft fruits are avidly stripped from the plants from mid-summer onwards, and the blackbirds are predominantly fruit-eaters until late autumn as the blackberries, elderberries, haws, and other fruits ripen. Fallen apples are a great attraction in autumn. Large numbers congregate at such food sources, but the blackbirds are not really gregarious. They tolerate each other during the autumn and winter, and may roost in fairly large numbers in the trees, but there is a good deal of half-hearted fighting and squabbling, with one bird suddenly rushing at its neighbour and chasing it a short distance away.

The females begin to adopt territories early in the autumn, although they do not defend them very strongly. Courtship may begin at about the turn of the year, but the males do not become strongly territorial until February, and then their mellow, but powerful songs can be heard nearly everywhere. The song is chirpy and cheerful, with many flute-like notes and with between six and nine repetitions of a phrase in a minute. It is usually delivered from a tree, with the bird sitting in a prominent position. The alarm call is a much harsher *chook-chook-chook* or *pink-pink-pink*, delivered as the bird flies off and with each sound louder than the last.

Breeding takes place from March onwards, when the females have moved into the males' territories and selected their nest sites. The female builds the nest single-handed anywhere from the ground to ten metres or more up in a tree. Dense hedges and creepers are often chosen, as are ledges and cavities in buildings.

The nest itself is a stout cup made of interwoven grass stems, thin twigs, and roots. It is lined with mud like the nest of the song thrush, but there is also an inner lining of fine grasses and dead leaves. Four or five eggs are generally laid and incubated by the female for about two weeks. The young remain in the nest for between twelve and nineteen days, during which time they are fed by both parents. They are also fed for a further two or three weeks after leaving the nest. The first brood is fed mainly on earthworms, but later broods receive mainly caterpillars.

Length: 25cm
Voice: Loud, flute-like song with trills. Main calls are 'chook-chook-chook' and 'pink-pink-pink'

The Robin

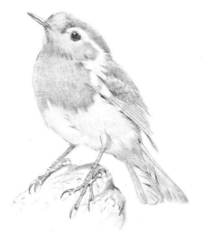

ROBIN

Erithacus rubecula

THE European robin is one of the best known and certainly the best loved of our garden birds. It is also one of the commonest British birds, although its very strong territorial behaviour ensures that you rarely see more than one in any given place. The bird never forms flocks in the way that many other birds do.

Robins breed almost everywhere in Europe apart from the far north, and they extend into North Africa and eastwards to the Caspian Sea. They are abundant in woodland, but in the British Isles they can be found almost everywhere that there is a reasonable amount of cover in the form of hedgerows, thickets, and scrubby vegetation. Garden hedges and shrubberies are fine for them, and the robins can even be found in towns as long as they are not too heavily built up. On the continent the birds are much more restricted to woodland, their place in the more open habitats being taken largely by redstarts.

As might be expected from a look at the robin's slender beak, the bird is largely insectivorous, but it is also very fond of worms and spiders, and it eats plenty of soft fruits and seeds when they are in season. You can tempt it to the garden bird table with all kinds of food, but the table must not be too far from a bush or a hedge, for the robin has a strong dislike of open spaces and rarely moves far from dense cover. It has an extraordinary weakness for mealworms, and if you can obtain a supply of these from the pet shop you can soon have your garden robin eating out of your hand. The bird is very bold and inquisitive and has little fear of man, as can be seen from the way in which it follows closely behind the gardener, searching for food in the freshly dug soil and perching on the fork handle at every opportunity as if to dispute ownership with the gardener himself.

M J PLEDGER

*T*HE robins begin to establish their territories at the beginning of August, straight after the summer moult. Both cocks and hens adopt territories and generally sing loudly to proclaim ownership. Both sexes also display the red breast prominently and readily attack any other robin that dares to invade the territory. The red breast is the signal for attack, and the birds will even attack bunches of red feathers hung up in their territories.

The birds start to pair up about Christmas time, with the female entering a male's territory and 'pestering' him to accept her. He will fight her at first, but if she is lucky he will eventually tolerate her presence. The female very often moves in with the male next door, and then their territories are pooled, forming a breeding ground of perhaps 5,000 square metres. This is vigorously defended by song throughout the day and often well into the night as well. Cock and hen virtually ignore each other for several weeks, and it is not until the hen starts to build a nest in late March or early April that the cock takes much interest. The hen builds the nest entirely by herself, however, choosing very sheltered places. Dense ivy is a popular site, but the birds also nest in outbuildings—even those in constant use—and they really do use old kettles shoved into a hedge. The nest is made of dead leaves and moss and generally lined with hair. Five or six eggs are laid and incubated for two weeks by the female. The youngsters stay in the nest for a further two weeks, being fed by both parents. There are generally two broods. Young robins do not acquire their red feathers until after the summer moult.

The territories break down at the end of June, when all the birds begin to moult. They all hide away and are rarely seen. They are not even heard for about a month, making July the only month in which robins are silent, but they soon start up again when they begin to establish their territories in August.

Length: 14cm

Sexes similar

Voice: A rather high-pitched, melodious warble. Alarm call a rapid 'tic-tic-tic' resembling the sound made by an angler's reel

The Goldfinch

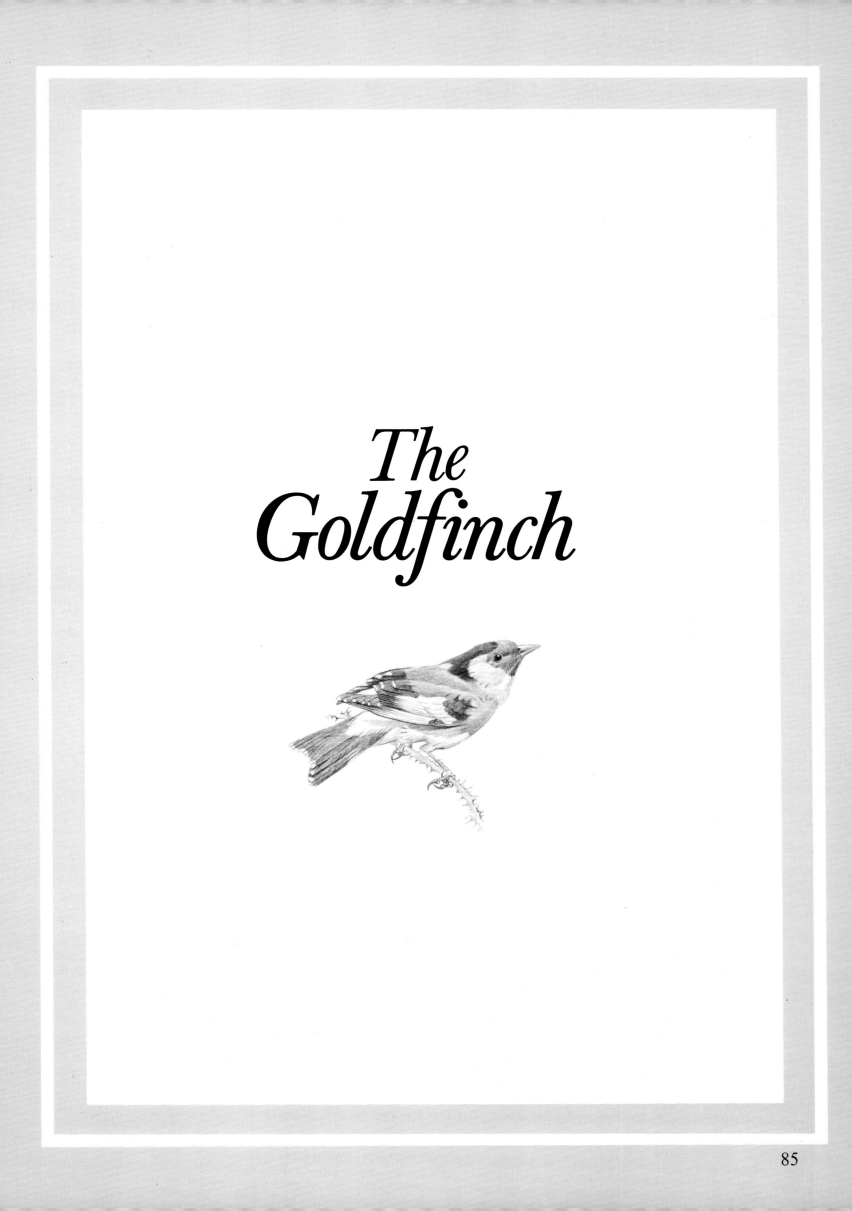

GOLDFINCH

Carduelis carduelis

THE goldfinch is one of the most beautiful of the European birds, easily identified by its red face, black and white head, and brilliant gold wing flashes. The female tends to have slightly less red on her face and she is slightly duller than her mate, but the two sexes are otherwise very similar. Goldfinches are absent from the northern part of Scandinavia, but found in most parts of Europe, in north Africa, and over a large area of western Asia. They are extremely common in the Mediterranean area, especially during the winter, when there is a big influx of birds from the north. The birds have also been introduced to Australia and New Zealand, where they have established themselves very well.

Goldfinches are found in open woodland and along the woodland margins, but they are essentially birds of cultivated and disturbed land, for it is here that they find the weeds on whose seeds they depend largely for food. They like the hedgerows and roadside verges, railway banks, abandoned quarries and rubbish dumps, rough grazing land, and coastal dunes. They are also frequent visitors to orchards and gardens, especially the wilder ones. The birds eat a wide variety of seeds, but get a large proportion of their food from thistles and other composites, such as dandelions, groundsel, knapweeds, and Michaelmas daisies. They also enjoy the seeds of the burdock and teasel. They are not keen on feeding on the ground, and they perform some amazing balancing acts on the plants while pecking furiously at the seed heads with their sharply pointed beaks. The wings are often used to maintain balance, as shown by the upper bird on the plate. Although seeds are their main foods, the goldfinches also eat a good deal of insects, especially in the spring.

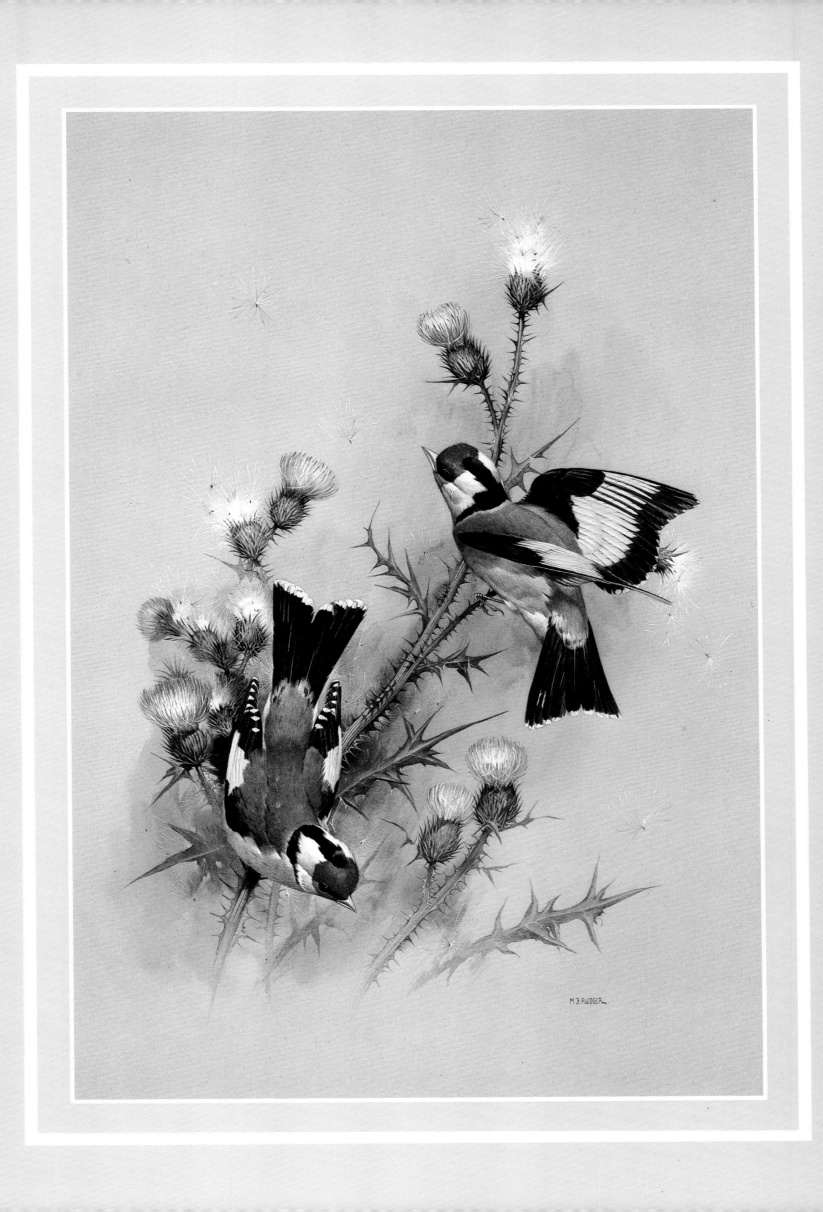

GOLDFINCHES are quite sociable birds outside the breeding season, often forming flocks of perhaps twenty or thirty and roaming the countryside in search of seeds. A patch of thistles swaying without any breeze will almost certainly contain a small flock—known as a charm—of these agile little birds busily extracting seeds. The birds sometimes join forces with other finches, such as linnets and greenfinches, for their winter forays.

The lilting, liquid song of the goldfinch is delivered from a tree or on the wing and can be heard throughout the year, although it is at its best in the spring. It consists of variations on a theme of *swit-swit-swit*, and the bird also has a rather harsh call of *geeze-geeze*.

Breeding begins in April or May, the nest usually being built in a tree between four and ten metres from the ground. It is generally constructed among the finer twigs towards the tips of the branches and it is in the form of a very deep cup to prevent the eggs from falling out in a strong wind. The male bird sometimes brings building material, but the female usually builds alone, using moss and lichen for the bulk of the cup and lining it with down, wool, and spider silk. She lays five or six eggs and incubates them alone for twelve or thirteen days. Both parents feed the chicks with regurgitated food, and the youngsters fly after about fourteen days, although they are dependent on their parents for a further week or so. They are speckly brown birds at first and do not get their bright head colours until they moult in the summer. There are generally two broods.

Length: 12cm
Voice: A lilting 'swit-swit-swit' and a harsh call of 'geeze-geeze'

The
Tree Creeper

TREE CREEPER

Certhia familiaris

THE tree creeper is a lively little bird that could be mistaken for a sparrow at first sight, but its long, curved beak and pure white belly readily identify it on closer inspection. It breeds in most of Europe and western Asia apart from the far north, although it is missing from western France and from the Iberian Peninsula. It is also common in North America, where it is known as the brown creeper.

Tree creepers are essentially woodland birds and they are most frequently seen scuttling nimbly up tree trunks, usually taking a spiral course and stopping at intervals to probe the bark crevices for insects. Like the woodpeckers, they use their stiff tails to brace themselves. They cannot run down the trunks again like the nuthatch can, and when they have got to the top of one trunk they swoop down to the base of another to begin again. The birds live in all kinds of woodlands, including coniferous plantations, but they are most numerous in mixed woodlands. They are not common in beech woods because the bark offers so few crevices. Mature gardens with large trees are occasionally visited by tree creepers, which sometimes search the fences as well as the tree trunks. Tree-lined avenues and well-wooded parks also support the birds, especially if the giant wellingtonia trees have been planted. The soft, fibrous bark of these trees hides plenty of insects, and the tree creepers also scratch out roosting holes for themselves. The bark acts like a blanket, and the existence of wellingtonias may well help to reduce the winter mortality of these little birds. Oak trees are also favoured, because their bark has deep fissures and also because the oaks support large numbers of insects in general. The tree creepers can be seen on them throughout the year, examining the twigs and branches as well as the trunks for aphids and other insects. They regularly give out their high-pitched call of *tseee* while foraging, and they also utter it on the wing.

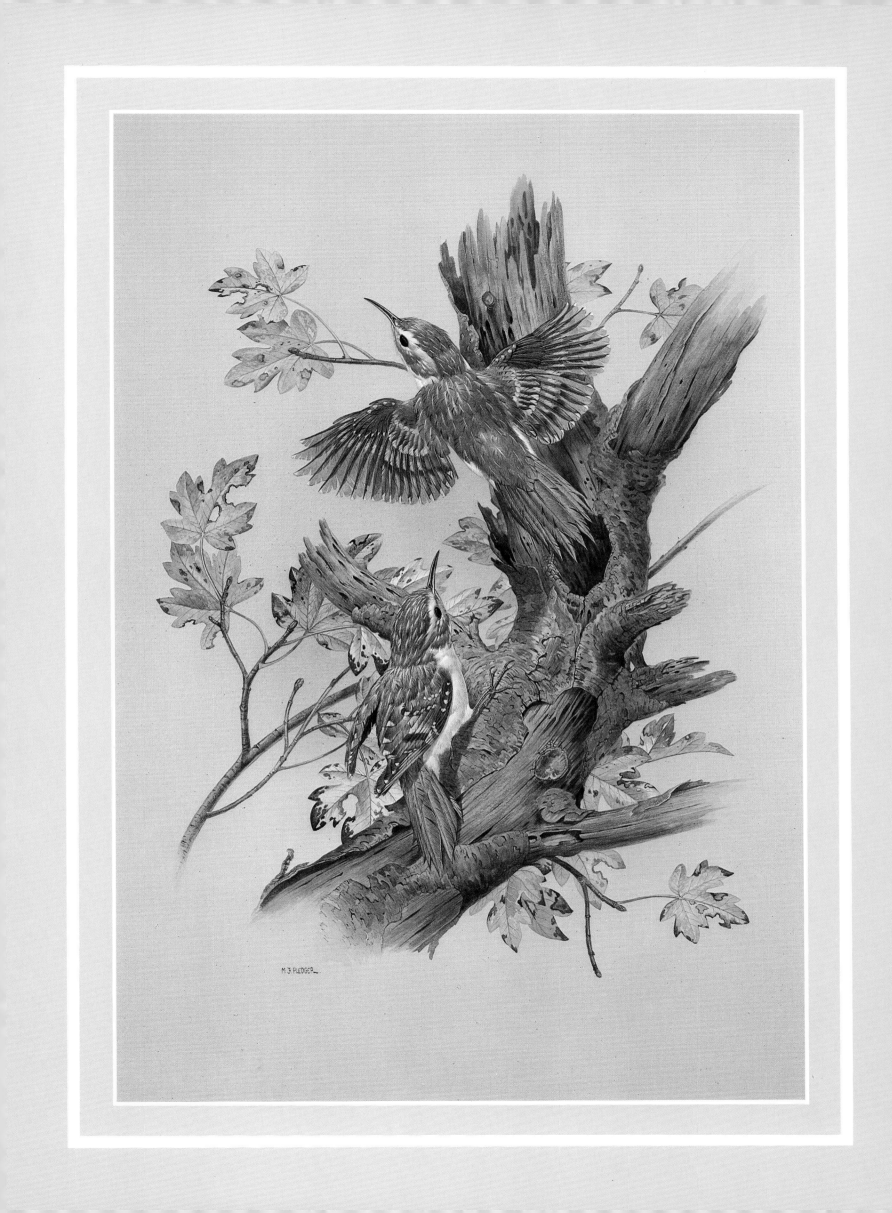

M J PLEDGER

DURING the winter, the tree creepers are nomadic birds, often moving about in small groups and frequently joining up with flocks of tits and other small birds in the woodlands. The males begin to establish territories early in March and soon come into full song—a rather high-pitched *tsee-tsee-tsee-tsissi-seepee*, which is repeated up to eight times a minute. Like the call, it is delivered from a tree or from the air. It can be heard in the late summer and autumn as well, but it is most frequent between March and June. Breeding usually begins in April, and the birds depend very largely on dead and dying timber for their nest sites. They generally build in cavities or behind loose bark, or occasionally in dense growths of ivy. Male and female work together to build a loose cup of twigs, roots, moss, and other plant material, which they then line with feathers, wool, and bark chips. Up to nine eggs are laid, and incubated entirely by the female. They hatch after two weeks, and the chicks remain in the nest for a further two weeks while they are fed by both parents. The youngsters can climb well as soon as they leave the nest, but it is some weeks before they can fly well.

Length: 12.5cm
Sexes similar
Voice: High pitched call of tsseee
Song: tsee-tsee-tsee-tssisi-seepee

The Cuckoo

CUCKOO

Cuculus canorus

THE European cuckoo is one of those birds that is far more often heard than seen. The male's penetrating call of 'cuc-coo' travels far and wide, but the bird itself tends to keep to the cover of trees and bushes. The female flies more in the open, but she does not utter the familiar call and she is rarely noticed. When she is seen, she is often mistaken for a hawk because of her narrow wings and long tail. Her song is a soft, bubbling noise that has been compared to the sound of wine being poured from a bottle. It serves to attract the male.

The cuckoo is a summer visitor to Britain, arriving from Africa in April as a rule, although occasional birds arrive much earlier. It can be seen in country gardens with high hedges, where it swoops to and fro in hawk-like fashion, snatching caterpillars and other insects from the leaves. It is one of the very few birds that eat hairy caterpillars. The hairs deter most birds because they irritate the mouth, but the cuckoo does not mind them. They stick in its gizzard wall and give it a furry lining.

The female cuckoo may have a more sinister reason for searching the hedgerow. It is well known that she does not make a nest of her own, and she may be looking for a suitable nest to parasitise. She spends long periods watching small birds building their nests, but she does not act until they have started to lay. She then nips in while the birds are away and lays one of her own eggs in the nest. She removes one of the original eggs in order to keep the numbers the same and the host birds do not seem to realise that anything is wrong, although the cuckoo's egg is slightly larger than their own eggs.

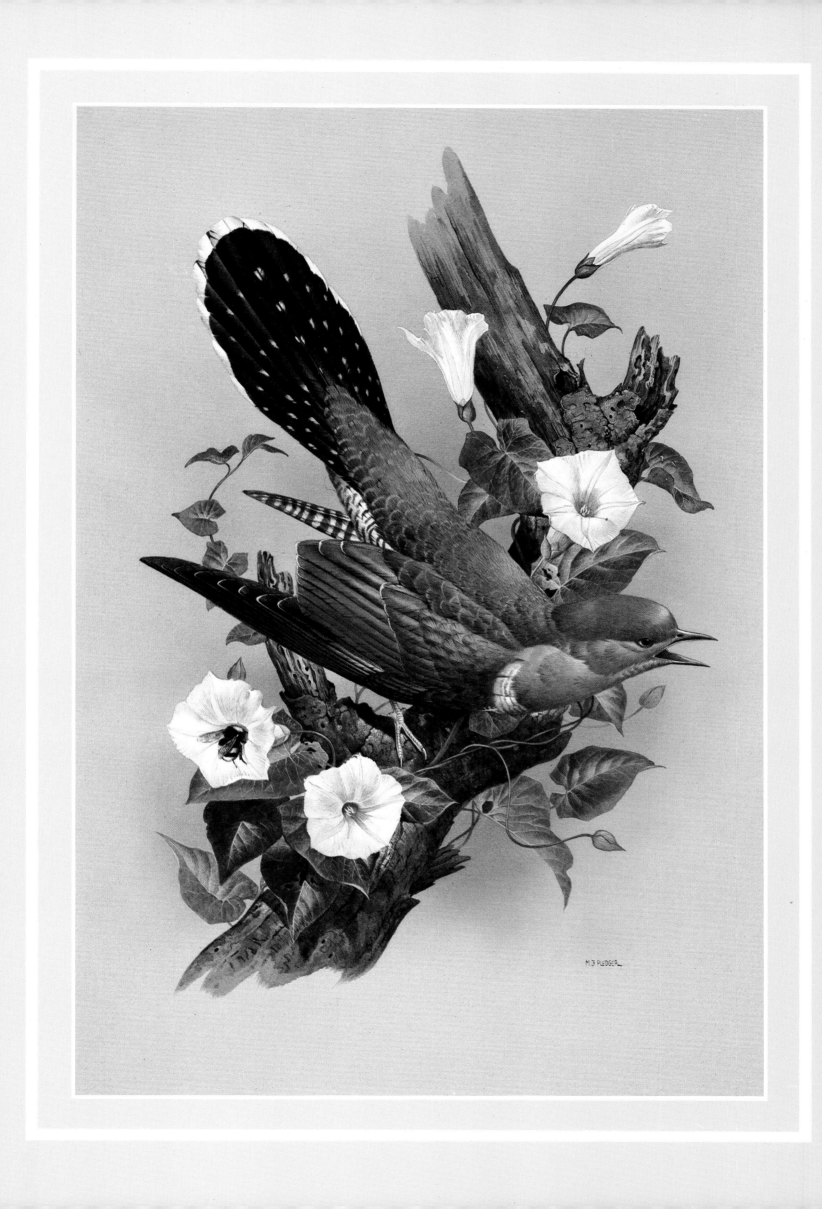

THE cuckoo lays anything up to twenty eggs, depending on the number of suitable host nests in her area. She never lays more than one egg in each nest. Among the birds most commonly chosen as foster parents for young cuckoos in Britain are dunnocks, wrens, robins, pied wagtails, meadow pipits, linnets, reed warblers, and sedge warblers. The British cuckoos all tend to lay mottled brown eggs, which are quite a good match for those of most common host birds except the dunnock. The latter generally lays clear blue eggs, but it still accepts a cuckoo egg quite readily. Several distinct races of the cuckoo can be recognised on the Continent, each specialising in a particular host species and laying eggs which bear a very strong resemblance to those of that host.

The cuckoo's egg normally hatches before any of the other eggs in the nest, and the young cuckoo's first task is to throw out the other eggs. It does this by getting its back underneath them and pushing them up until they roll over the edge of the nest. The foster parents then put all their efforts into feeding the young cuckoo. It grows very quickly and is soon larger than they are. They may actually perch on its head to push grubs down its throat. The youngster outgrows the nest in about three weeks and it struggles out to perch on a branch. The foster parents continue to feed it for a further two weeks, by which time it can fly and catch food for itself.

Adult cuckoos fly back to Africa in July or August, having stopped singing by the end of June. The youngsters follow a little later, guided by the sun and the stars and by instinct.

Length: 33cm

Sexes similar

Voice: The familiar 'cuc-coo' in the male; a soft bubbling sound in the female

The House & Tree Sparrow

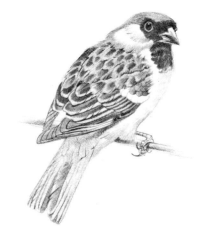

HOUSE & TREE SPARROW

Passer domesticus & Passer montanus

*T*HE house sparrow and the tree sparrow are two very closely related and very similar birds, but they are easily separated by looking at the head. The tree sparrow, seen centre right on the plate, has a brown crown and a black cheek patch in both sexes, while the male house sparrow, seen on the left of the plate, has a greyish crown and no cheek patch. The female house sparrow, at the top of the plate, is a dull brown bird with very few distinguishing marks.

To a town dweller, the house sparrow must seem to be the most abundant bird in the country, and many gardeners might get the same impression, but in fact the house sparrow is no more than about sixth on the list. It is very rarely seen away from human habitation, and it is believed that about 80 per cent of the country—all the woodlands and open hills and much of the pasture land— are completely lacking in house sparrows. The bird is primarily a grain eater and it originated on the grasslands of Africa, but it has followed man to almost every part of the world and has virtually become a scavenger around our houses. It breeds in every inhabited part of Europe, but it is doubtful if the bird could survive here without man.

The house sparrow is a very noisy bird, especially in the breeding season, when the males chase the females through the hedges and shrubs. It has no real song, however—just an assortment of *cheeps* and *chirps*. It is a very gregarious bird and, although it rarely forms massive flocks, it is unusual to see a solitary house sparrow. Throwing food into the garden will usually bring half a dozen or more birds scampering down to investigate and perhaps to indulge in a tug-of-war over a choice morsel.

M.J.PLEDGER

HOUSE sparrows sometimes nest in hedges, but they usually build on or in houses—generally tucked up under the eaves or amongst creepers, or else in the roof space. They always nest in loose colonies, with perhaps a dozen or more pairs living on a few adjacent houses or even on one large house. Only the immediate vicinity of the nest is defended against other sparrows. The birds mate for life, and having once nested they also remain faithful to their nest sites. If one of a pair dies, the remaining bird, whether male or female, stays with its nest and merely obtains a new mate from among the younger, unmated birds.

The nest is usually an untidy heap of grass and straw and any other materials that the birds can find but it has a warm lining of wool or feathers. The male does most of the building, and where the nest is in a roof space or similar cavity he simply adds more material to the existing pile each year. The female usually lays between three and six eggs from the end of April onwards. She does most of the sitting during the two weeks of incubation, and then both parents feed the nestlings—mainly with insects—for a further two weeks. The male continues to feed the young for a week or so after they have left the nest, during which time the female is busy with a second clutch of eggs. There are usually three broods. Country birds generally go off to the grain fields for a while after the breeding season, but they rarely go more than a few kilometres from home, and they soon return to their homes. The older birds usually roost in their nests and can be seen taking new material to them throughout the year. Town-dwelling birds do not go off to the fields and they find sufficient food by scavenging in litter bins and similar places.

The tree sparrow is much more of a woodland bird, and it is found in gardens only if they have plenty of trees. It breeds in holes or among thick creepers and its breeding biology is much the same as that of the house sparrow, but it is much less gregarious.

Length: House sparrow 14.5cm
Tree sparrow 14cm
Voice: Shrill cheeping and chirping in both species

The House Martin

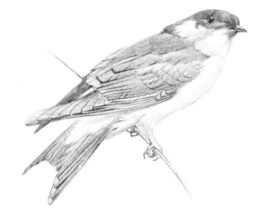

HOUSE MARTIN

Delichon urbica

THE house martin is a close relative of the swallow, but it is easily distinguished by its much shorter tail—resembling that of a fish—and by the lack of any red on the throat. Like the swallow, the martin is a summer visitor to Europe, normally arriving from Africa from mid-April onwards and staying until October or even November. It breeds all over Europe, along the North African coast, and in a narrow belt running across central Asia to Japan. The house martin was originally a cliff-nester, and many birds still breed on cliffs, but the species is now very common in towns— much more so than the swallow because it is happy to nest on ordinary dwelling houses. But the birds must have mud with which to build their nests, and this bars the martins from some of the most densely built-up areas.

The nest is shaped like half a deep cup and it is firmly cemented to a wall, usually right up under the eaves or some other overhang so that there is just a small opening at the top. It is composed of pellets of mud strengthened with plant fibres, and it is lined with feathers and plant fragments. Both members of a pair help with the building, collecting mud from the edges of ponds and streams or park lakes and carrying it back in their beaks. If you want to encourage these interesting birds to nest on your house and there is no pond nearby, it is a good idea to provide them with a supply of mud by heavily watering an area of the garden each day. The birds tend to nest in loose colonies, with several nests close together or even touching each other. There may be fifty or even a hundred nests on a large building such as a school, especially if the eaves have a wide overhang, but the birds swoop unerringly into their own nests when they return from feeding sorties.

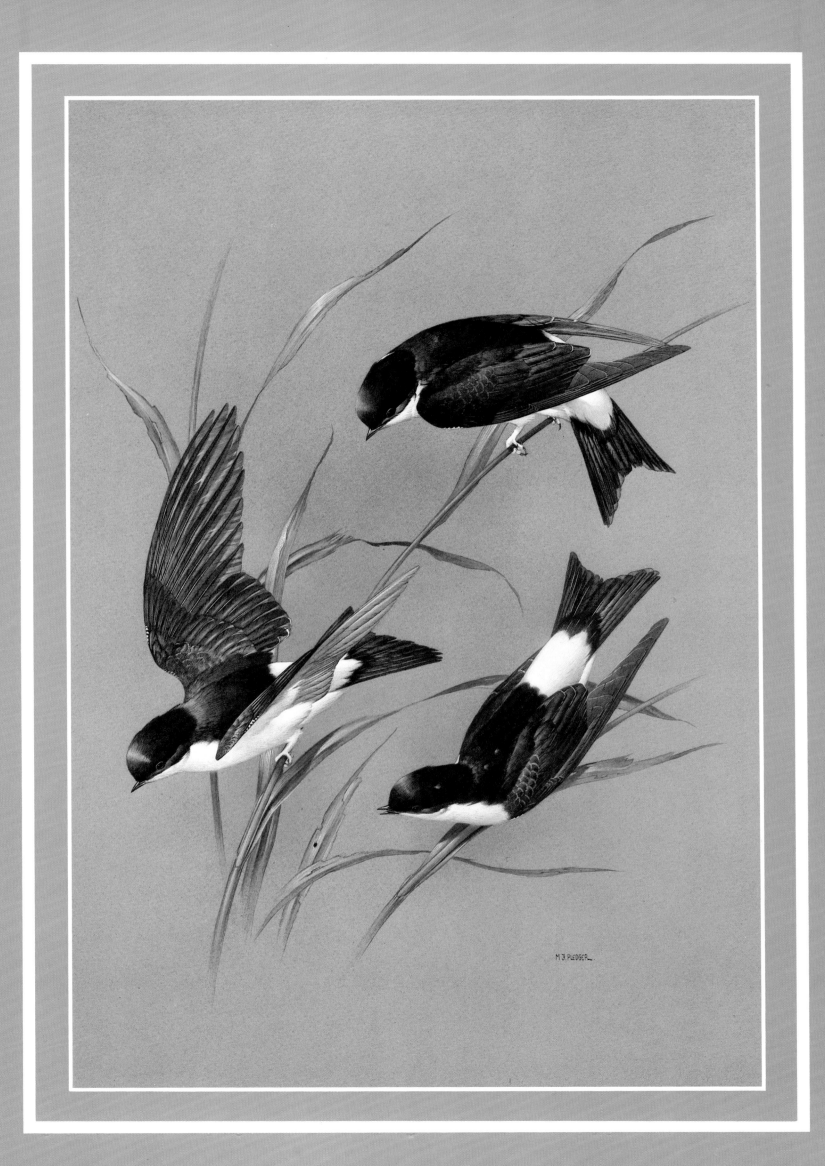

*H*OUSE martins spend almost every minute of daylight in the air, although they rarely travel far from their nest sites: they merely swoop to and fro at heights of up to 150 metres or so and scoop up small insects in their wide-open beaks. They often perch on wires and buildings, but very rarely on the branches of trees. Some occasionally feed on the ground, and it is believed that certain colonies do this after discovering insects on the ground while collecting mud for their nests. The birds utter a soft, twittering song while perched or while flying, but their commonest call is a staccato chirp.

Four or five eggs are laid from late May onwards and incubated by both sexes for about fourteen days. The young birds are fed by both parents, which carry beakfuls of insects to the nest with amazing regularity. The parents go right into the nest when the chicks are very young, but later they cling to the outside and can be seen stuffing the insects into gaping beaks which are thrust out of the nest to meet them. The youngsters can fly at about three weeks, but they usually remain with their parents for some time and often help to feed the young of the next brood. There are usually two broods and often three.

By ringing the birds, ornithologists have discovered that the house martins usually return to the same nest sites each spring. If the house sparrows have not already taken over the nests, the martins actually use their old homes, indicating that they have remarkable memories and navigational abilities. The old nests may need a little repair, but, being built up under the eaves where they are sheltered, they suffer little damage from the weather and remain serviceable for several seasons

Length: 12.5cm
Sexes similar
Voice: A soft, twittering song and a chirping call.

The Common Redstart

COMMON REDSTART

Phoenicurus phoenicurus

THE European redstart is a relative of the robin and the blackbird and quite unrelated to the American redstart. The males, two of which are having a territorial argument on the plate, are easily recognised in the breeding season by their black necks and faces and their red breasts. They are much duller in the winter. The female has a greyish brown head and back and a fawn breast and belly throughout the year, but she has an orange-brown tail like the male.

Redstarts are summer visitors to Europe, spending the winter in the grasslands just south of the Sahara. They arrive in Britain in April and the males usually precede the females by a few days. This gives them a chance to establish their territories, and they soon launch into their rather varied warbling song, which they then keep up until the middle of June.

The birds breed all over Europe in woodlands, orchards, parks, and gardens. They tend to favour the less disturbed areas of woodland and scrub in Britain, but on the continent they are very happy to take up residence around human habitations. They even nest in out-buildings, and in Germany they are actually called 'garden redstarts'. They are restless birds, spending most of their time flitting from perch to perch among the trees. Even when perched, they seldom remain still, for they are always bobbing up and down or jerking their tails.

Redstarts are essentially insectivorous birds and they catch a very wide range of insects, both in the air and on the ground or the vegetation. They often dart out from their perches to snatch passing flies rather like flycatchers, and they even capture quite large butterflies in this way. Large numbers of caterpillars and beetles are taken from the leaves, and the birds also feed readily on spiders, woodlice, and other invertebrates.

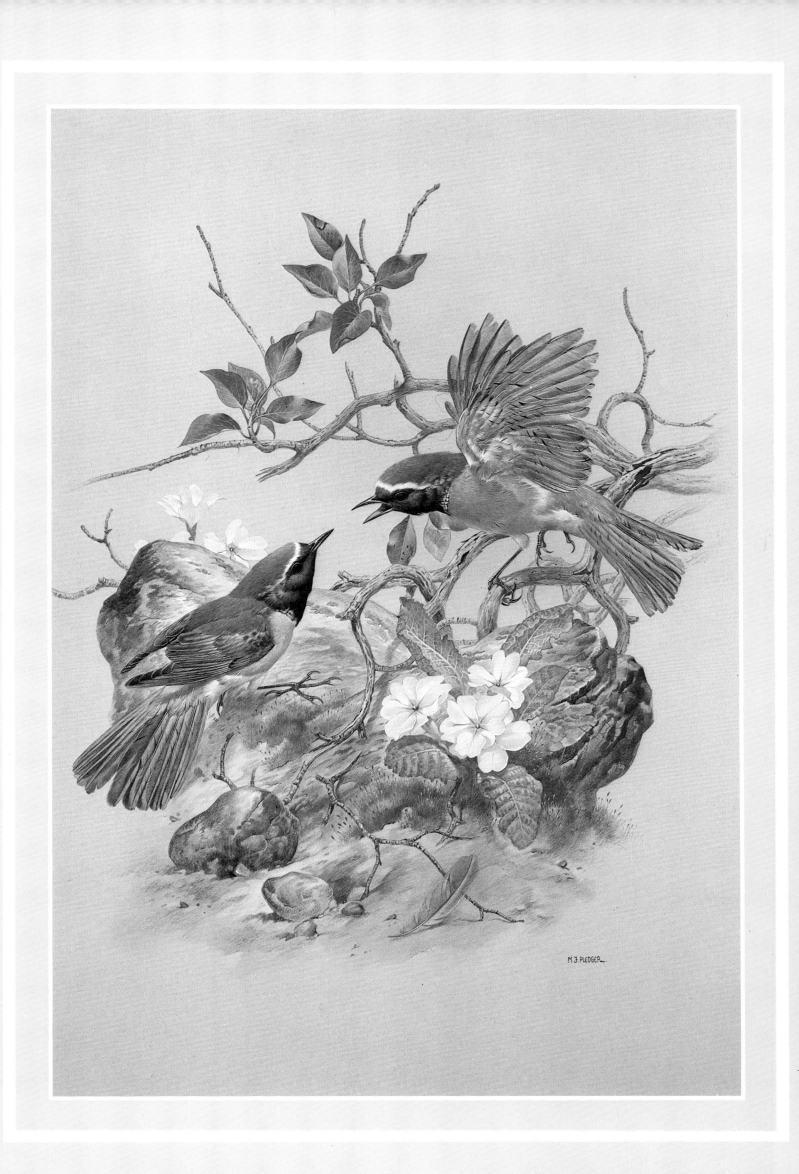

M J PLEDGER

THE male redstart uses his song and his bright coloration to defend his territory against other males, but when a female arrives in his territory his thoughts turn to courtship. He fans his tail and displays the orange feathers, and she may do the same. She then flies rapidly away, still displaying her tail feathers, and the cock follows. Many such chases take place during the courtship period and they serve to establish the pair-bond. The male has usually selected a potential nest site before the arrival of the female and, after a few days of chasing her through the trees, he leads her to the site by means of a colourful display involving his tail feathers and his boldly marked head. The site is always a cavity or a deep crevice—an open-fronted nest box is ideal—and the male ensures that his mate notices it by darting in and out and showing off his colours at the entrance.

If the female accepts the nest site, she begins to build the nest. The male may bring a few twigs and other materials, but the hen does all the actual building. The finished nest consists of a cup of moss, grass, hair, and feathers on a foundation of twigs. Mutual displays continue throughout the nest-building period and eventually lead to mating. The hen then lays about six eggs around the beginning of May. She lays somewhat later in the more northerly regions, and also lays more eggs. This is quite common among birds, for the longer days in the north enable them to collect more food and thus rear more young. The eggs are incubated for about two weeks by the female alone, with the male on guard nearby and singing most of the time. The male brings all of the food during the nestlings' first few days of life, but then both parents collect food. The youngsters leave the nest after two weeks, but they are fed for a few more days and they generally keep together for several weeks. A second brood is raised in the southern parts of the range.

Length: 14cm
Voice: Song is a varied warble; Main call is 'wee-tuk-tuk-tuk'

Printed and bound by Morrison & Gibb
Limited, Edinburgh.

Colour separations by Newsele Litho Limited,
London and Milan

Typesetting: South Bucks Typesetters Limited,
Beaconsfield